IMAGES
of America

THREE VALLEYS OF
THE TEHACHAPI
BEAR, BRITE, AND CUMMINGS

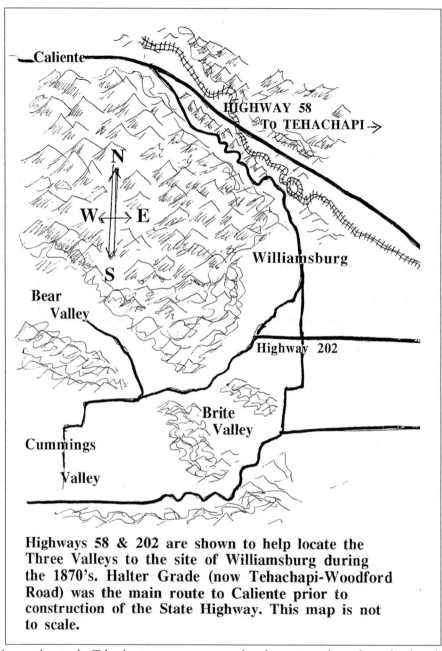

Highways 58 & 202 are shown to help locate the Three Valleys to the site of Williamsburg during the 1870's. Halter Grade (now Tehachapi-Woodford Road) was the main route to Caliente prior to construction of the State Highway. This map is not to scale.

The first settlers in the Tehachapi area were attracted to the virgin soil, good grassland, and ample water of the Three Valleys. In 1869, James Williams created a small village (Williamsburg), which soon offered their services needed for a growing community. (Courtesy author.)

ON THE COVER: If buildings could talk, this shed on the Fickert Ranch in Bear Valley would have a multitude of tales. Sisters Louise and Nellie were the last of the Fickert children to live on the ranch and, following World War II, had the 1870 family home modernized. It was preserved as a private residence by Dart Industries and is occupied today. (Courtesy Flo Sussell.)

IMAGES
of America

THREE VALLEYS OF
THE TEHACHAPI
BEAR, BRITE, AND CUMMINGS

Gloria Hine Gossard

ARCADIA

Copyright © 2005 by Gloria Hine Gossard
ISBN 0-7385-3026-3

Published by Arcadia Publishing
Charleston SC, Chicago IL, Portsmouth NH, San Francisco CA

Printed in Great Britain

Library of Congress Catalog Card Number: 2005927047

For all general information contact Arcadia Publishing at:
Telephone 843-853-2070
Fax 843-853-0044
E-mail sales@arcadiapublishing.com
For customer service and orders:
Toll-Free 1-888-313-2665

Visit us on the internet at http://www.arcadiapublishing.com

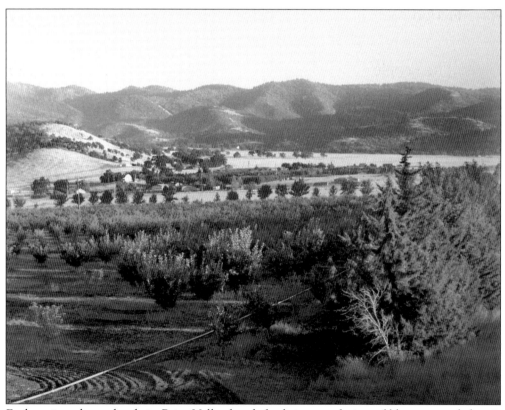

Each spring, the orchards in Brite Valley break forth in a profusion of blossoms and the air becomes rich with their fragrance. Orchards of apples and pears were first planted here in the 1800s. (Courtesy Barbara Tieskoetter, R&B Orchards.)

CONTENTS

ACKNOWLEDGMENTS

Compiling this book could be compared to a historical reenactment for, like history, it required the joint efforts of many to make it happen.

There were those who came forth with assistance in many forms: computer skills, proofreading and editing, courier services, researching data, and providing photographs. All helped in the production of this book.

Our sincere thanks to the following (in alphabetical order): Charles Basham, Edison Historical collection; Bear Valley Springs Association (BVSA) for the Dart collection; John Carnakis; Matthew Chew; Jerrie Cowan, Tehachapi Heritage League; Bill Donica; Rick and Donna Drucker, *The Cub*; Joe and Lea Fontaine (descendents of an early settler); Kathy Furn, National Museum of the Morgan Horse; Rudy Groothedde, California Thoroughbred Breeder's Association; Carol Homes, *Tehachapi News*; Barbara Mason; Karem Miller, Western Horseman; Judy Muell (former secretary to Justin Dart of Dart Industries); Jeff Nickell, curator, Kern County Museum; Judy and Bob Reynolds; Nick Smirnoff; Teri Spencer, *The Mountain Signal*; Flo Sussell; Becky Swiggums, Tejon Ranch Company; Tehachapi Soil Conservation District; Barbara Tieskoetter, R&B Orchards and Tehachapi Grower's Association; U.S. Department of Agriculture; Barbara Whelan; and Jim Yurk.

Originally each of the Three Valleys had their own schoolhouse. Today the Bear Valley School (c. 1872–1900) is the only one remaining. Therefore, it is only fitting that this book on the historical background of Bear, Brite, and Cummings Valleys will be used to raise funds for the restoration and preservation of the one-room Bear Valley Schoolhouse.

We thank you for your interest and contribution to this cause.

—Gloria Hine Gossard

INTRODUCTION

For over a century, the Tehachapi Pass remained far removed from Spain's colonization of California. It is a natural passage between the southern Sierra Nevada and the Tehachapi Mountain Range, which separates the Mojave Desert from the San Joaquin Valley.

First trod by the native inhabitants, it wasn't until 1772 that it was "discovered" by Don Pedro Fages while pursuing fleeing mission neophytes. Four years later Padre Francisco Garces followed his native guides through this pass. In his journal he described it as a land with "conifers, oaks and other trees."

In 1827, Jedediah Smith became the first known American to use the pass. Smith was the leader of a fur-trapping expedition that had come into Southern California via Texas and Arizona. Three years later other fur trappers led by Ewing Young followed this trail. Among those in the party was a young Kit Carson who returned in 1837. This time he was a guide for the United States Army Corps of Engineers led by Lt. John C. Fremont, who would describe the area as "a highly cultivated garden."

In 1845, the slogan "Manifest Destiny" swept through the eastern states. Hundreds looked to the West as an opportunity to acquire free land and start a new life. By 1848, this was intensified with the discovery of gold in California. A veritable flood of emigrants headed west. For those taking the Southern Immigrant Trail (the route used by the earlier fur trappers), the Tehachapi Valley became their passage to the gold fields of Northern California. For many, however, their trail ended here for they soon discovered the truth behind those descriptive words written by Padre Garces and Lt. Fremont.

As these travelers explored the area, they soon discovered they were on a vast plain divided by several small ranges. At the west end of the valley, these mountains had created three valleys with rich and fertile soil. There were a number of creeks, small shallow ponds, and an abundance of conifers and oaks. For those aching to put down their roots in good farmland and cattle country, the search was over. By 1860, the area became known as the Three Valleys of the Tehachapi: Bear, Brite, and Cummings Valleys.

When the Southern Pacific Railroad entered the Tehachapi Plain in 1876, their depot became the nucleus for a new town that grew into the City of Tehachapi. Among those pioneers contributing to the city's growth were the settlers of the Three Valleys of Tehachapi. This is their story.

Looking west into the San Joaquin Valley from the mountains of Cummings Valley (at the apex of the old Sheep Trail) provides the same vista that was seen by such early travelers as Padre Francisco Garces (1776), Jedediah Smith (1827), and John Charles Fremont (1844). (Courtesy Nick Smirnoff.)

John Brite gave his name to this valley in 1860 after selling his 1854 homestead on Tehachapi Creek. A government survey described this valley as "first quality for farming purposes with fine springs." It is the smallest of the three valleys as it is less than one mile long and three and a half miles wide. The elevation is around 4,000 feet. (Courtesy author.)

Cummings Valley is named for another early settler, George Cummings, who first saw it while herding cattle north to the gold fields in 1849–1850. In 1854, he returned and established his own cattle ranch. This is the largest of the three valleys. It is six miles long, two and a half miles wide, and ranges in elevation from 3,000 to 3,800 feet. (Courtesy Tehachapi Heritage League.)

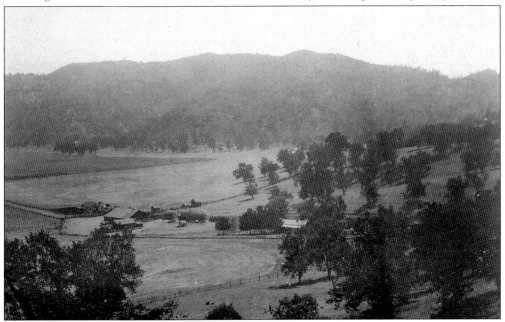

Bear Valley lies west of Brite Valley and north of Cummings Valley and was so named due to the numerous bears (both Grizzly and black) who made this and Bear Mountain their home. It is a little over three miles long, two miles wide, and its elevation is from 4,300 to 5,000 feet. (Courtesy Tehachapi Heritage League.)

9

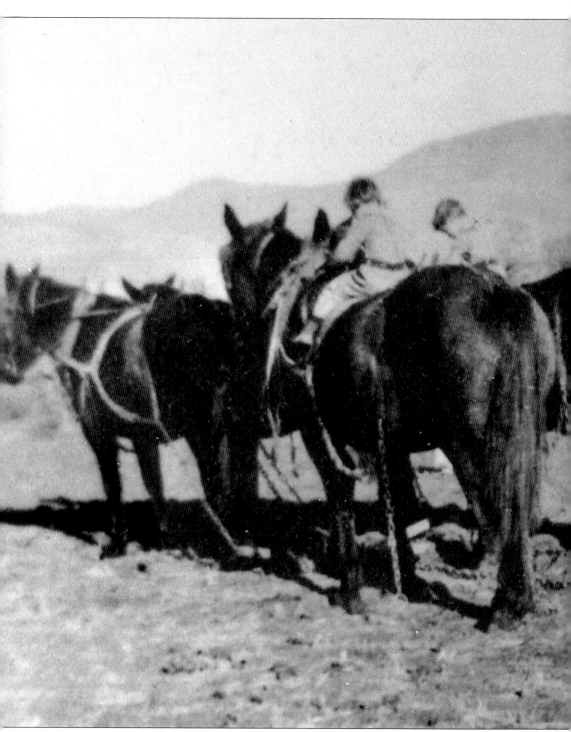

Families were particularly attracted to the Three Valleys. The rich fertile soil, abundant timber and grasslands, numerous springs, and small ponds promised rich rewards for those unafraid of hard work. In 1875, the *Kern Weekly Courier* reported, "We spent four days in an excursion [of] Tehachapi, Bear and Cummings Valleys. We found a large population and more improvements

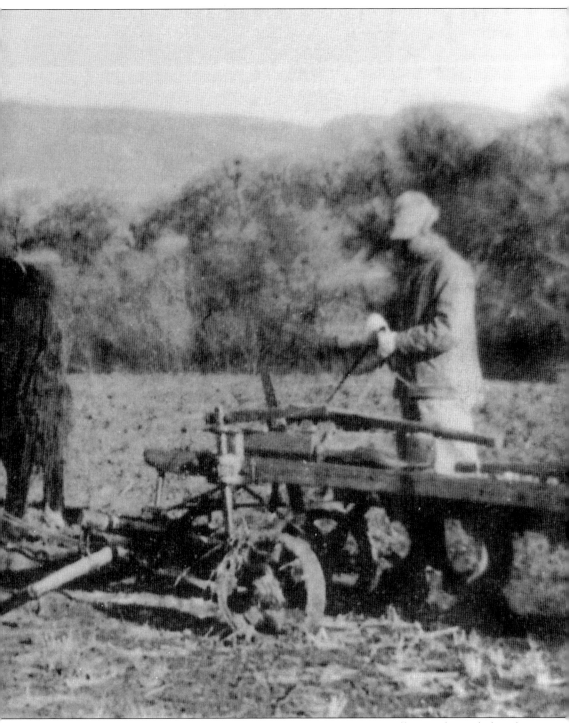

then we had expected to see, but as the country is extensive it is still sparsely settled and the hand of man has done little more than make a visible impression." (Courtesy Tehachapi Heritage League.)

Boulders pockmarked with mortar holes indicate a former Kawaiisu campsite where women once ground acorns into a coarse meal. It also indicates a source of water that was used to leach the bitter toxin from the acorns. A hollow would be scooped out in the damp sand of a creek bed and a layer of the meal, about one-half inch deep, placed inside then saturated with fresh water and allowed to stand for several hours until the water had soaked through. The meal, now suitable to eat, was scooped out. (Courtesy Tehachapi Heritage League.)

One

THE PEOPLE

They called themselves the Noo-ah, "The People," and they claimed to have come from the land. They were a gentle band of hunters and gatherers. Years later, anthropologists named them Kawaiisu and classified them as a branch of the more aggressive Paiutes who lived in the Owens Valley and the Nevada desert.

Acorns were their primary diet, and their home was the vast valley they called Teh-hach-apa or—"land of the acorns." During the summer, they ranged the smaller valleys fringing this Tehachapi Plain gathering acorns, pine nuts, and grass seeds, and hunting deer, rabbits, and quail. During the winter, they moved to a large canyon located at the eastern end of this large valley. Protected here from the fierce Mojave Desert winds, the weather was less severe. They could hold their religious ceremonies at this site they called Tomo-Kahni or "winter home."

Throughout the Three Valleys, only boulders with deep mortar holes now remain where once the women gathered to grind acorns. The site of their winter home, however, has been preserved as Tomo-Kahni State Park. It is open only during the winter months for reservation-only, guided tours.

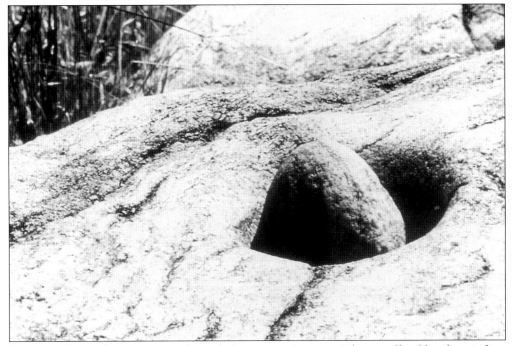

Some grinding rocks serve as significant links to an ancient past. The use of boulders for grinding seeds is said to have occurred around 6,000 B.C. and indicates the first use of seeds by a people who previously subsisted primarily by hunting. (Courtesy Tejon Ranch Company.)

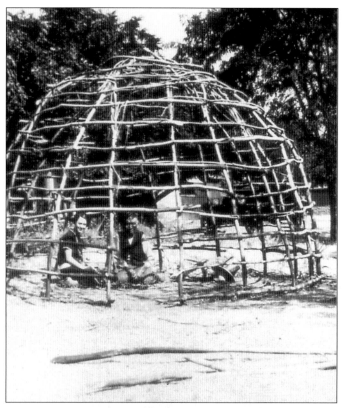

The permanent home of the Kawaiisu was their winter house, which sheltered and protected the family during the stormy days and long, cold nights of winter. It was constructed in a circular fashion with willow poles tied together both vertically and horizontally (as shown here). The vertical poles were tied loosely at the top to allow a smoke hole. The intervening spaces were packed with brush, and woven grass mats served as a door, flooring, and bedding. Inside they settled around a warm fire and told stories or caught up with such tasks as making cordage, new arrows and arrow heads and, for the women, making new baskets. (Above courtesy Tejon Ranch Company; below courtesy Tehachapi Heritage League.)

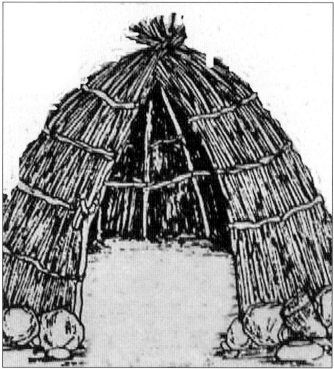

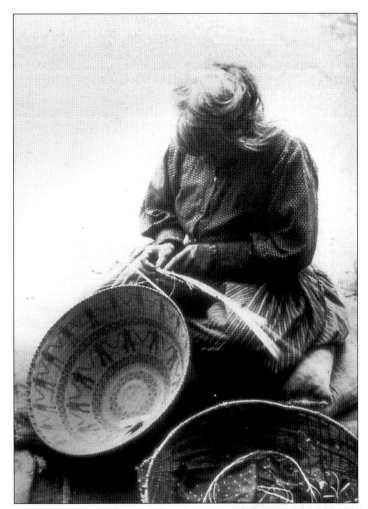

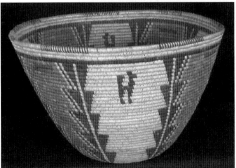
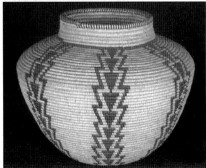

Baskets took the place of pottery, and Kawaiisu women became artisans in this field. Using willow and other pliable materials, they constructed both coiled and twined baskets for carrying, storage, and cooking liquids and mush. The latter was accomplished by dropping hot stones into contents of the basket, which had been constructed of a fine, tight weave that would swell with moisture. The baskets were not only utilitarian, but each was an expression of the maker's artistic talents by incorporating colors and patterns depicting the world in which they lived. (Above courtesy Tejon Ranch Company; below both courtesy Tehachapi Heritage League.)

A respected elder of the Noo-ah, Andy Greene (1916–1999) was named Native American of the Year by state legislators in 1989. Born and raised in the Tehachapi area, he spent his boyhood years with his grandmother at Nettle Springs in Sand Canyon. Here he learned, first hand, the lore and heritage of his ancestors. In later years, he served as the unofficial guardian of Nettle Springs and surrounding areas, which had been the Kawaiisu's winter home. Working with [then] state assemblyman Phil Wyman and members of the Tehachapi Heritage League, he pursued a campaign to preserve this area that several anthropologists and archaeologists had called the "most significant Noo-ah cultural area in existence." In 1993, the state acquired this site and adjoining acres for a total of 50 square miles. In 1994, it was officially designated as Tomo-Kahni State Park. Green was honored as the park's first employee. (Courtesy Tehachapi Heritage League.)

Two

WILLIAMSBURG

James Williams first homesteaded in Bear Valley. In 1867, he purchased a section of land in the west end of the Tehachapi Valley. In anticipation of playing host to the forthcoming Southern Pacific Railroad, he laid out a three-street town site at the base of Black Mountain and named it Williamsburg. The main street was called Bullion and was intersected at each end by Main and Tehachapa Streets. People of many backgrounds and various trades arrived, and it soon became the commercial and trading center of the area. Within a few years, the town was flourishing with two hotels, a livery and blacksmith shop, a drug store, mercantile store, and numerous saloons.

As the railroad progressed up the Tehachapi grade, travelers came through Williamsburg and wrote glowing accounts of its future. A stage from Los Angeles to Caliente stopped here, as did many teamsters hauling ore from the Owens Valley mines to the rail heads in the San Joaquin Valley. Because it was the only town located in the vast valley, many called it Tehachapa (the old spelling) instead of Williamsburg. But by 1876, it became apparent that the Southern Pacific railroad had no intention of making Williamsburg its depot. The company had already marked a location some six miles east of Williamsburg. They named it Summit Station and within a few years businesses and residents alike packed up and moved to Summit, which soon adopted the name New Tehachapi. Williamsburg then became known as Old Town and slowly withered away. Six months after the arrival of the railroad and several years before the last business moved on, James Williams died in December 1876.

By 1875, Williamsburg had gained considerable attention from newspapers in the area. The *Havilah Miner* called it " a town already with some importance" and described the site as a "commanding location, not only to the Owens Valley Road but will, eventually, be the greatest grain growing portion of the county." (Courtesy Tehachapi Heritage League.)

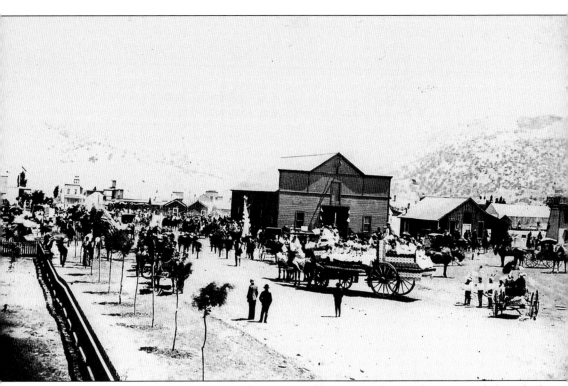

Not everyone praised the new town. The *Kern Weekly Courier*, (November 23, 1872) described Williamsburg's hotel, schoolhouse, blacksmith shop, two stores, and a saloon as follows: "The schoolhouse is creditable, the only good building in the place. The rest having the usual shanty look of the new California mountain towns." Within three years, however, Williamsburg had grown, and a visitor to the area described the town to be "quite lively," with two hotels plus a livery stable, a watch repair shop, a stationary and drug store, and three new saloons. Sunday was the "big day," with people pouring in on horseback and wagons until the "little town seemed about to explode." (Courtesy Kern County Museum.)

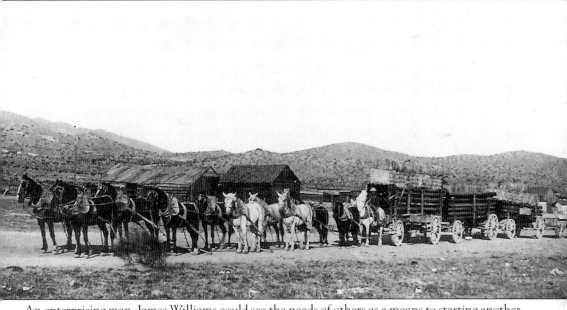

An enterprising man, James Williams could see the needs of others as a means to starting another business. In 1873, he expanded his regular trips to Bakersfield for supplies into a weekly express service. Leaving Williamsburg on Monday morning and returning late Tuesday, he also carried mail, express matters, and packages for others—all at a fee. (Courtesy Tehachapi Heritage League.)

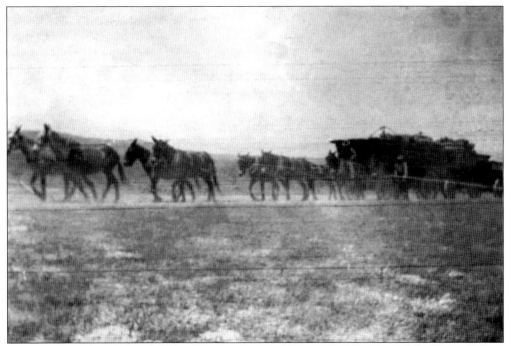

Prior to 1870, when Bakersfield became a commercial center, early settlers of the Three Valleys had to travel to Visalia or Los Angeles for supplies. The journey took several days, since both cities were over 100 miles away. (Courtesy Tehachapi Heritage League.)

Fred Boden opened a blacksmith shop in Williamsburg and became one of the town's first businessmen. He later moved to the new Tehachapi and purchased some property further west along White Rock Creek, which he intended to farm. In 1894, he sold this to his son Louis and moved on to Garlock. (Courtesy Tehachapi Heritage League.)

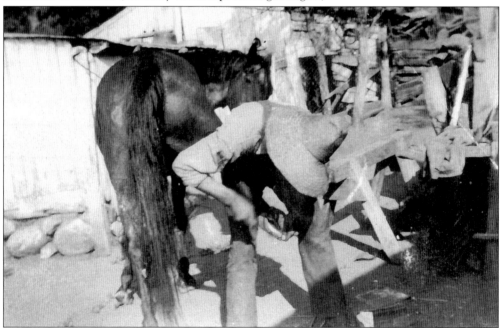

A blacksmith was kept busy making shoes for horses, mules, and oxen; repairing rims on wagon wheels; and forging iron into plow shares. The art of shoeing a horse was not, however, confined to the blacksmith. Ranchers such as Joe Banducci (seen here) became, out of necessity, adept at shoeing their own horses. (Courtesy Tehachapi Heritage League.)

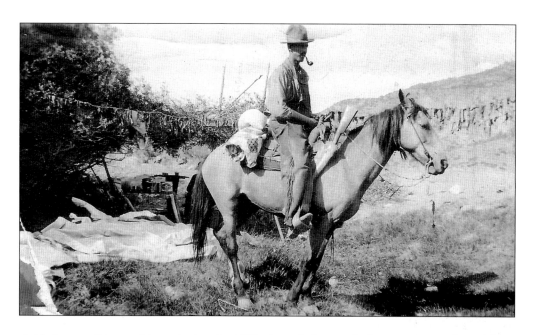

Aside from walking, residents during the 1800s depended upon the horse, either under saddle or in harness, for transportation. While circulating a petition to create a new county out of portions of existing Tulare and Los Angeles Counties, John Brite and Ezekiel Ewing Calhoun used horses to travel from their ranches in Bear and Brite Valleys. On April 2, 1866, state legislators approved the new County of Kern. The county seat was Havilah, located between Walker's Basin and Kernville. Brite became this area's first supervisor and Calhoun the county's first district attorney. Both men had to commute between their homes and the county seat on horseback or in a buggy. (Both courtesy Tehachapi Heritage League.)

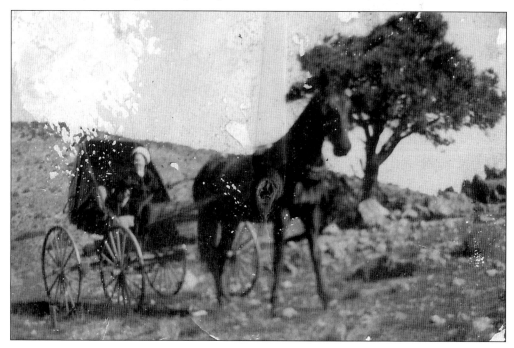

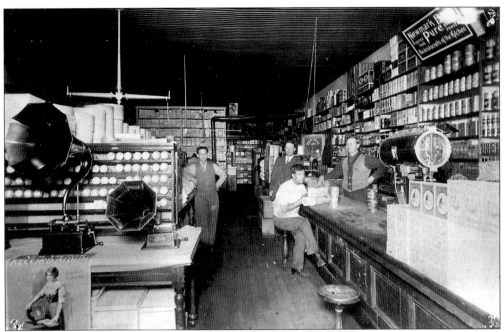

One of the first stores to open in the new town was a mercantile store owned by J. J. Murphy, He was already well-known throughout Kern County with stores operating in Kernville, Glennville, and Havilah. Inside his store, a customer's nostrils would tingle with the mixed aromas of whole coffee beans inside burlap bags, new leather saddles and harnesses, bolts of calico cloth, plump dill pickles in wooden barrels, and jars of hard candies. (Courtesy Tehachapi Heritage League.)

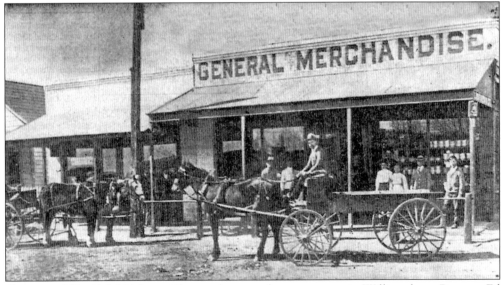

Greene and Hirschfield Mercantile was the second store to open in Williamsburg. Partners Ed Greene and Abe Hirschfield were by far the most aggressive in promoting their business. In 1875, local newspapers advertised their large stock of general merchandise that included staples such as coffee, tea, flour, and sugar, and cooking utensils, farm equipment, coal oil, and candles. The store delivered to any family within 10 miles. (Courtesy Tehachapi Heritage League.)

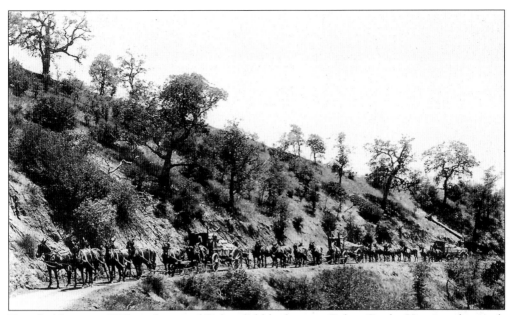

Travelers between Williamsburg and Bakersfield had to use Halter Grade. Hugging the north slope of Bear Mountain, it followed and crisscrossed Tehachapi Creek and was, in certain areas, extremely steep. Descending wagons had to lock the rear wheels and either drop the tailgate or drag a heavy log as an extra brake. Even with such precautions, accidents happened. A local newspaper reported a man died when he fell from the wagon seat and was run over by his own wagon. (Courtesy Kern County Museum.)

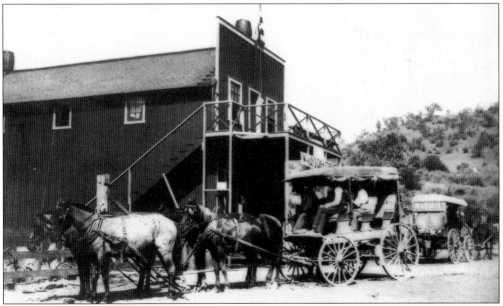

By April 1875, the Telegraph Stage Line was making daily trips between Los Angeles and Havilah, with mail and passenger stops in Williamsburg. A passenger paid $20 for the full trip, which took a total of 33 hours. Although the coming of the railroad curtailed such travel, Thomas A. Neeley opened a stage line between Summit Station and Old Town (Williamsburg) carrying mail, packages, and passengers who paid 50¢ for the ride. (Courtesy Tehachapi Heritage League.)

23

Warehouses were built to accommodate the abundant grain harvests from the three valleys. A visitor once reported seeing a long line of wagons waiting for their cargo to be unloaded. But not all grain was stored for shipment. William Baker opened a grist mill with the capacity to produce up to 75 barrels of flour a day, and Joseph Strauss opened the Tehachapi Brewery, which converted locally grown barley into 600 gallons of beer per day. (Courtesy Unwin collection, Tehachapi Heritage League.)

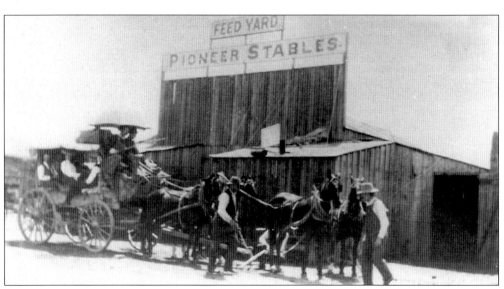

Livery stables were the early equivalent of today's car rentals and often advertised their services to attract new customers arriving in town by stage. The *Kern Weekly Courier* (January 1, 1876) noted, "Mr. C. McVicar conducts a livery stable where handsome buggies and good teams are available at reasonable prices." (Courtesy Kern County Museum.)

The Errea House was one of the many buildings that was moved when its occupants left Old Town for the new Tehachapi. The frugal and industrious pioneers jacked up their homes, and mounted them on logs that rolled across the dusty plain behind a team of muscular mules to the new location, which, for this Errea House, became Green Street. Today it serves as offices of the Tehachapi Heritage League. (Courtesy Tehachapi Heritage League.)

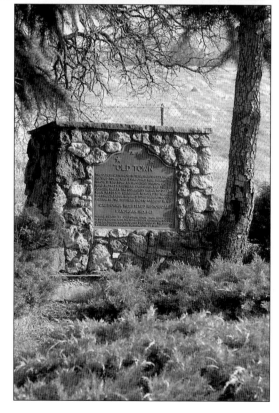

Even after the railroad bypassed Williamsburg, optimism remained high. Many business continued "as usual." In 1877, James Eastwood erected a windmill and piped water into his Valley Hotel to provide the area's first indoor bathroom with running water. But all was in vain. By 1885, Williamsburg was no more. Today all that designates the site is this stone monument located on the Tehachapi-Woodford Road. (Courtesy Nick Smirnoff.)

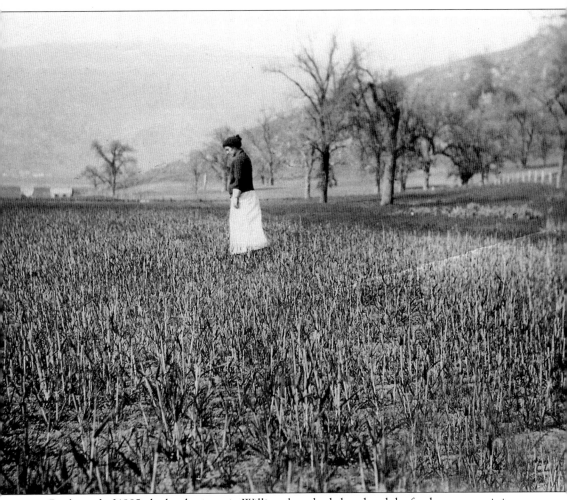

By the end of 1885, the last business in Williamsburg had closed and the few houses remaining were given away for their removal. The land reverted back to meadows and was incorporated into adjoining ranches. Only the schoolhouse remained, and this too was eventually demolished. Williamsburg never became a ghost town. It just ceased to exist. (Courtesy Tehachapi Heritage League.)

Three

LIFE IN THE 1800s

Who were these early settlers? What brought them to these valleys of Tehachapi and how did they live? Some, such as George Cummings, were single. He first discovered the area while driving a herd of cattle north to the gold camps in 1850–1851. Only after he returned three years later and went into ranching, did he marry and raise a family. John and Amanda Brite and their first born traveled overland from Texas in search of a place to settle and raise their family. They arrived here in 1854 to become the area's first permanent family. Frederick Fickert left Prussia for a life at sea, until he reached San Francisco. After marrying an Irish lass, he worked his way south searching for gold until, in 1869, he discovered his real treasure in Bear Valley. Starting with just 160 acres, he had, by 1900, acquired most of the valley.

Living concentrated on the basic needs. Families had to be self sufficient, raising and preserving their own food while learning to live with both drought and floods. Rough around the edges, they still demanded an education for their children, religion for their souls, and a voice in local politics.

"The people of Tehachapi, Cummings and Bear Valleys came here relatively poor as a general thing, but by marked industry they have built up pleasant homes and are wearing an air of independence," wrote *The Gazette* on May 20, 1876.

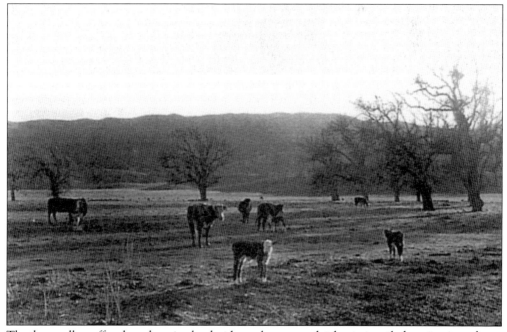

The three valleys offered good grazing land with ample water and rich, virgin soil; the prime ingredients for those seeking to raise cattle or engage in farming. (Courtesy Dart collection, BVSA.)

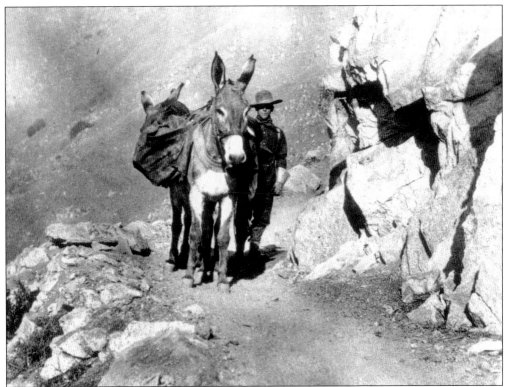

Who were these individuals who first settled in these three valleys? Some were bachelors traveling through the area while en route to the gold fields of Kern River or Northern California. They traveled light, their belongings carried on a sole pack animal. Years later some, like Francois Chanac, would return to settle near a creek that still bears his name. (Courtesy Edison Historical collection.)

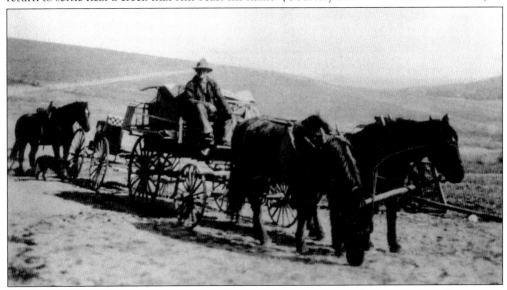

Others were somewhat more prosperous and needed a wagon to carry their possessions. Sometimes a man's wife would drive the wagon team while he rode horseback and herded the family's livestock. (Courtesy Tehachapi Heritage League.)

Not everyone planned to farm or raise cattle. Los Angeles newspapers carried overblown reports of periodic gold strikes, fanning the dreams of many seeking to "striking it rich." A few made some significant finds, but the majority found their bonanzas in the land. (Courtesy Unwin collection, Tehachapi Heritage League.)

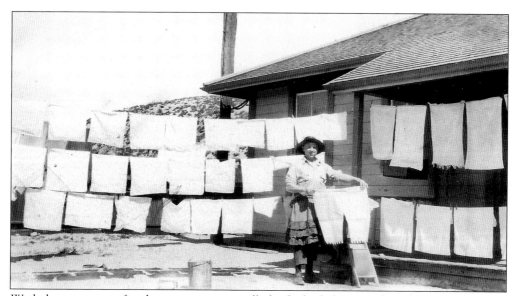

Wash day was not confined to women—especially for the bachelors. Frank Nedja took a humorous approach to this chore and had his picture taken wearing a frilly apron and holding up a pair of bloomers. (Courtesy Tehachapi Heritage League.)

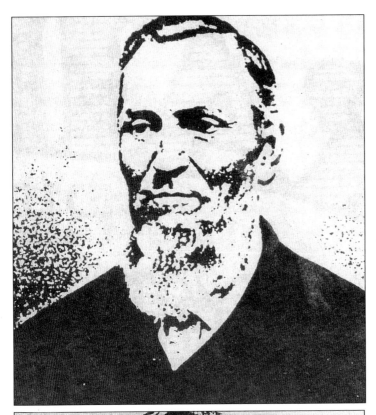

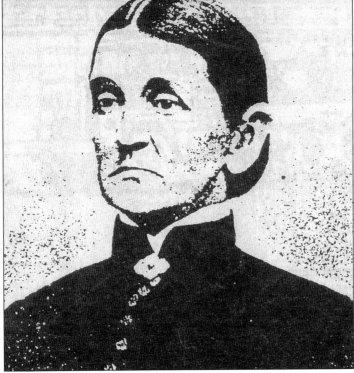

John Moore Brite was born August 9, 1820, in Calloway County, Missouri. As a young man he ventured into Texas where he met 16-year-old Amanda Emaline Duty. The couple was married November 22, 1849, and four years later they, and their two infants, joined other hardy Texans bound for California. The trip took seven months and three weeks, during which there was a brush with Apaches and a trail side burial of an infant daughter. They arrived in El Monte in 1854, then continued on to the Tehachapis where they become this area's first permanent white settlers. (Courtesy Tehachapi Heritage League.)

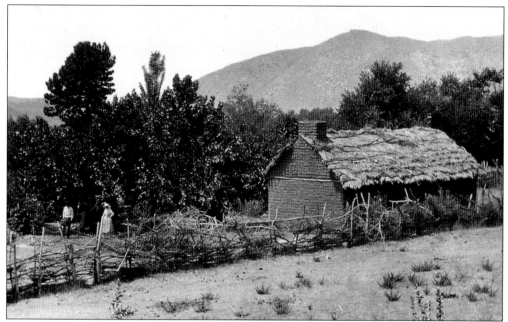

The Brite's first home on Tehachapi Creek was a small log cabin. In 1869, they moved to Brite's valley where John built an adobe house for his growing family. Out of 13 children, 10 would live through adulthood. To supply water to the ranch, a 300-foot tunnel tapped into a mountain top spring noted for its purity and excellence. The water flowed downhill through wooden troughs until 1960. (Courtesy Tejon Ranch Company.)

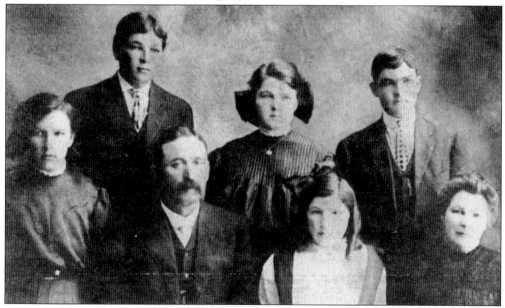

Lucas Franklin (Gabe) Brite was the fourth child born to John and Amanda and raised in their adobe house. With 640 acres, he started his own ranch and, in 1885, married Laura Smith who had been born in Cummings Valley. This family portrait (taken around 1906) shows Gabe (front row, second from left) and Laura (front row, far right) and their children (left to right) Bonnie, John Perry, Bertha, Ruby, and Vance. (Courtesy Tehachapi Heritage League.)

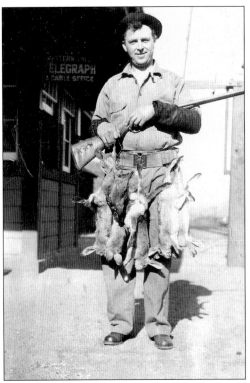

Life in the 1800s was not easy and until crops could be harvested and cattle sold there was little, if any, income. The settlers (such as this rabbit hunter) often depended upon the abundance of wild game to help feed their growing families. (Courtesy Tehachapi Heritage League.)

Not everyone was a good shot, and ammunition was expensive and not always readily available. Neighbors would combine talents as trackers and hunters for a deer hunt. The meat would be divided among them so that all would benefit and not one shot had been wasted. (Courtesy Tehachapi Heritage League.)

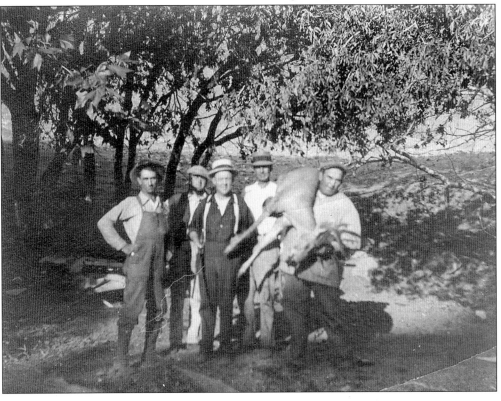

Adobe was the building material of the Southwest and the most common method of constructing a home. Despite the rough appearance, these mud brick walls insulated the house and kept the interior cool in the summer and retained heat during the winter. (Courtesy Tehachapi Heritage League.)

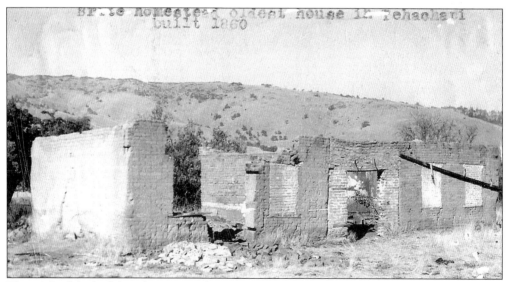

This 1869 adobe built by John Brite withstood the elements until the mid 1900s, when this picture was taken. Many of the early adobe structures in Cummings Valley were later saved from such a fate by constructing a wooden frame on the exterior walls and plastering the inside. (Courtesy Tehachapi Heritage League.)

CATTLE BRANDS of 1850's–1900's

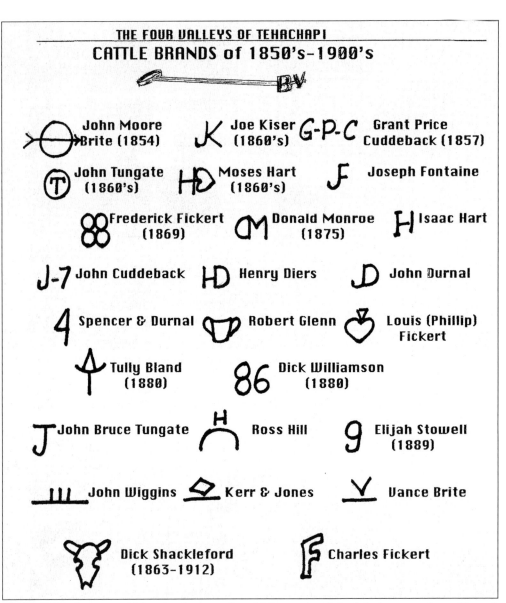

John Moore Brite (1854)

Joe Kiser (1860's)

G-P-C Grant Price Cuddeback (1857)

John Tungate (1860's)

Moses Hart (1860's)

Joseph Fontaine

Frederick Fickert (1869)

Donald Monroe (1875)

Isaac Hart

J-7 John Cuddeback

Henry Diers

John Durnal

4 Spencer & Durnal

Robert Glenn

Louis (Phillip) Fickert

Tully Bland (1880)

86 Dick Williamson (1880)

J John Bruce Tungate

Ross Hill

9 Elijah Stowell (1889)

III John Wiggins

Kerr & Jones

V Vance Brite

Dick Shackleford (1863–1912)

Charles Fickert

By the 1870s, there were 15 families living in Bear Valley and each had their own registered brand. The process of branding cattle as a means of identifying ownership was introduced to the New World during the 1770s by the Spanish colonists. Since the Three Valleys was open range, the herds of the early settlers intermingled and branding was a necessity. (Courtesy author.)

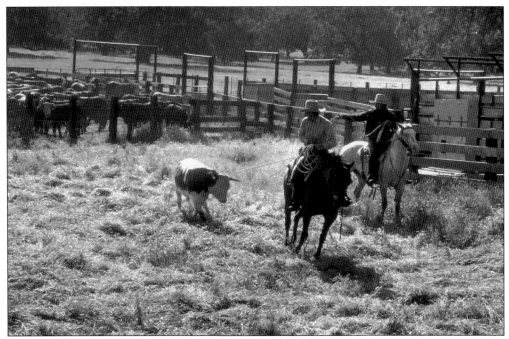

Roundups were a joint operation. Collectively the combined ranches of the Three Valleys area ran thousands of cattle on close to a million acres. Tejon Ranch alone had over 97,000 acres as did the Tehachapi Cattle Company. John Cuddeback, Dick Shackleford, John Durnal, Harv Spencer, and the Brites ran cattle on 12,000 acres, and Ezekiel Calhoun owned 6,000 acres in Bear Valley. (Courtesy Tejon Ranch Company.)

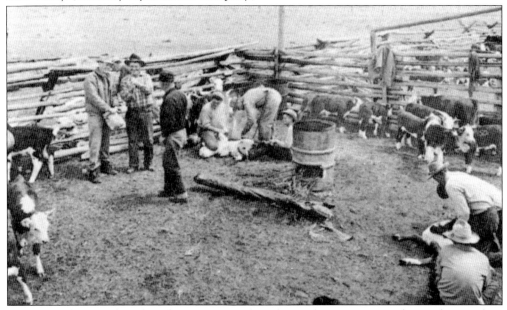

Once a herd was gathered in the spring roundup, the cattle were separated according to their brands. Cows with calves were driven into a large corral where the calves could be roped and branded with each operation recorded in the owner's tally book. (Courtesy U.S. Department of Agriculture.)

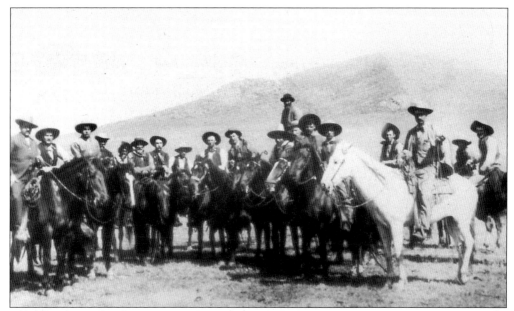

Roland and Russell Hill were among those who learned their horsemanship skills from the Mexican vaqueros who worked for the nearby Tejon Ranch. The vaqueros had perfected their craft from the early Spanish rancheros. Roland and Russell's father, Ross, realized this and had his boys start working with the vaqueros at a very early age. (Courtesy Tejon Ranch Company.)

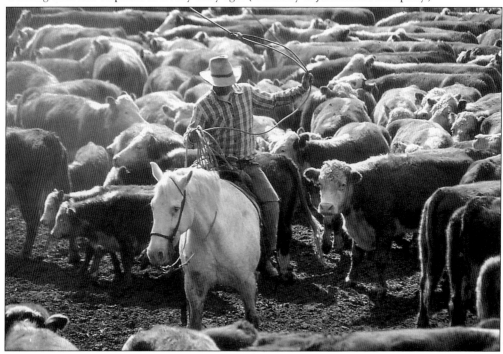

A harsh winter in the mountains would often mean good grazing in the desert. John Durnal, Harv Spencer, and the Brites would gather their collective herds, numbering between 6,000 to 8,000, and drive them east to the Mojave Desert for late winter and early spring grazing. (Courtesy Tejon Ranch Company.)

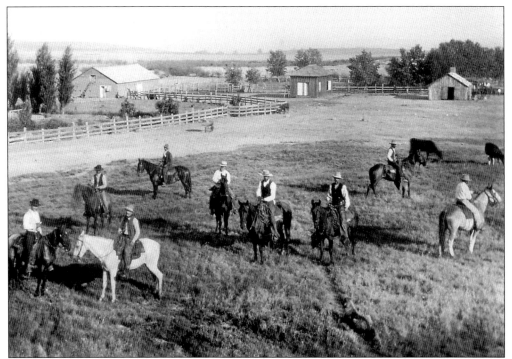

It took a special kind of person to be a cowboy. Tully Bland was such a man. Born in Los Gatos, California, he began his career at an early age in Northern California before coming to the Three Valleys. When the railroad arrived, he hung up his spurs to work as a freight conductor. After three years, he had saved enough money to buy a place in Bear Valley. He married Sarah Hart and settled down to raise crops, livestock, and children. (Courtesy Tejon Ranch Company.)

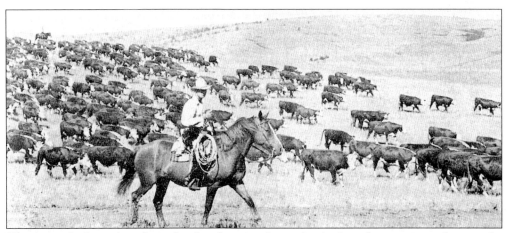

Water was the key to good grassland and raising fat cattle. At first, this was more than ample, and a census taken in 1860 listed close to 1.3 million head of cattle in this area. But within a few years, California was in the throes of a major drought. Water holes and creeks disappeared into sand and grasslands withered to dust. Hundreds of cattle perished. By 1870, the number remaining had dropped to just 6,700 head. (Courtesy U.S. Department of Agriculture.)

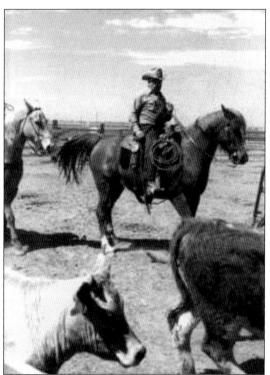

E. J. "Bud" Cummings carried on the ranching tradition established by his grandfather, George Cummings, who gave his name to a mountain and the valley where he established his ranch. Following the birth of a son, George and his wife moved back to Los Angeles where they had interests in several businesses. Their son Edward G. returned to the ranch after his father died in 1903, married, and raised another generation to run the family's ranch. (Courtesy Tehachapi Heritage League.)

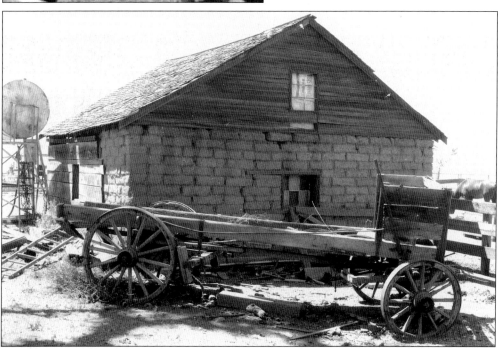

By 1889, the Cummings Ranch included 3,300 acres and was engaged in raising grain, cattle, and horses. In 1967, Gov. Ronald Reagan designated it as a California Historical Ranch with membership in the One Hundred Year Club. It has remained in the Cummings family. (Courtesy Tehachapi Heritage League.)

Cowboying was not a fair-weather job. Cattle had to be checked during the winter to keep them from huddling in canyons where they could be blocked by deep drifts of snow, ice had to be chopped from water holes, and weakened stock herded down to the home ranch so they could be fed hay. (Courtesy Tehachapi Heritage League.)

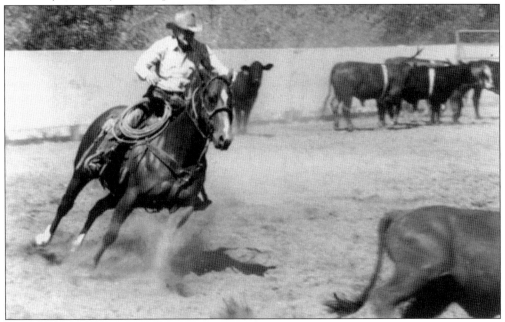

There was no age or racial discrimination among cowboys. If you could ride a horse and endure the many hardships, you could become a cowboy and earn the "magnificent" sum of $15 to $20 a month, plus room and board. The winter pay could drop to $10 and if times were bad, perhaps just room and board. (Courtesy Kern County Museum.)

The Hart family were among those who first settled in this area before going on to leave their legacy elsewhere (Hart Flat and Bakersfield's Hart Park). In 1794, the patriarch, Josiah, was born in Hardin, Kentucky. By 1820, he was hunting buffalo in Texas. In 1854, he came to California, and in 1858, settled in Cummings Valley. He and his sonsengaged in freighting between the mines along Kern River and Los Angeles. It was during one of these trips, July 3, 1863, that they were attacked by Paiutes. Martin Hart was shot in the head and died instantly. His step-brother Oliver Burke was seriously wounded, but lasted long enough to provide cover for the others to escape. Josiah later settled in Cummings Valley. Josiah and Grace Hart are seen here in this undated photograph. (Courtesy Kern County Museum.)

Moses and Julia Findley Hart pose for this c. 1907 photograph. Moses, son of Josiah Hart and brother to Joseph, Martin, Aaron and Isaac, survived the 1863 attack in Kelso Valley. Along with Aaron and Isaac, he first saw the Three Valleys in 1854 while working for a government survey party. Moses returned and settled on 160 acres in Bear Valley, next to his brother Isaac's ranch. Their property was known as Hart's Field and included land where Bear Valley Community Services District offices stand today. Aaron was killed in 1861 on Christmas Day while trying to break up an argument between two friends. (Courtesy Kern County Museum.)

The ever-industrious John Brite not only engaged in ranching, but early in the 1860s joined Mr. Remington and Judge Hamilton to open the area's first sawmill. It had the capacity to turn out 1,000 feet of lumber per day. By 1875, four sawmills, located in Brite Canyon, Water, and Antelope Canyons, were in operation. (Courtesy Tehachapi Heritage League.)

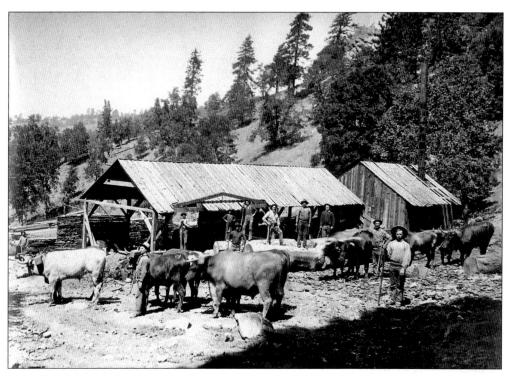

Oxen were used to bring the cut timber down to the steam-powered mills to be sliced into boards. Brite once purchased mining property in Water Canyon solely for the water rights needed to power his lumber mill. (Courtesy Tehachapi Heritage League.)

Not all trees were cut down for lumber. As the area grew, there was an increased need for firewood; the railroad needed fuel for its engines and a burgeoning lime industry needed wood for the kilns. Crew members were kept busy cutting trees into firewood, which sold for $5.50 a cord on the ground. One oak tree (similar to this shown) could supply 20 cords of wood. (Courtesy Tehachapi Heritage League.)

Brite's sawmills were kept busy supplying both rough and finished lumber to the growing number of residents and their businesses. It was sold at the mill for $15 to $20 per thousand feet, and for an additional $5 was delivered locally. (Courtesy Kern County Museum.)

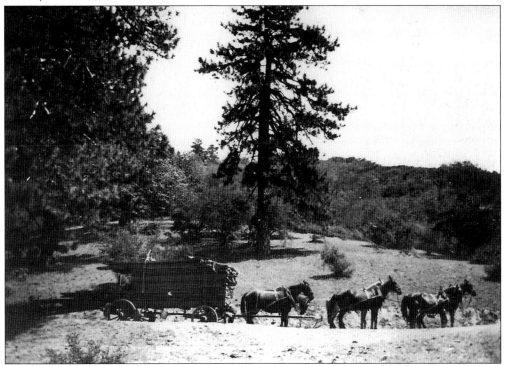

Frederick William Fickert was born August 27, 1830, in Prussia. At the age of 15 he went to sea and within five years became a provision master on a merchant ship. In 1850, his ship arrived in San Francisco and he left his seafaring years to seek his fortune in the gold fields of Sierra, Butte, and Kern Counties. (Courtesy Rick and Donna Zucker, *The Cub.*)

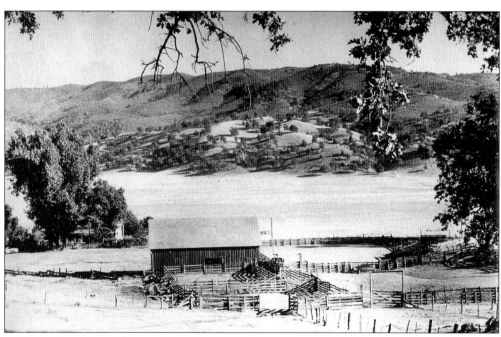

While residing in Havilah, Fickert ran a livery stable, but after it had burned down twice (1868, 1869), he decided to move on. He discovered Bear Valley and purchased 160 acres from James Williams. Here he found his fortune and for years called the valley his Garden of Eden. Ultimately he would own it all. (Courtesy Tehachapi Heritage League.)

Mary Glynn Fickert was born March 27, 1839, to Thomas and Mary Tooley Glynn of Barney's Slough, Ireland. In 1859, she and her five sisters, accompanied by a brother-in-law, arrived in San Francisco via New York and the Isthmus of Panama. Here she met Fred Fickert, whom she married on December 19, 1861. For the next 19 years, she accompanied him on his search for gold. Along the way she gave birth to three children—Louis, Thomas, and Louise. (Courtesy Rick and Donna Zucker, *The Cub.*)

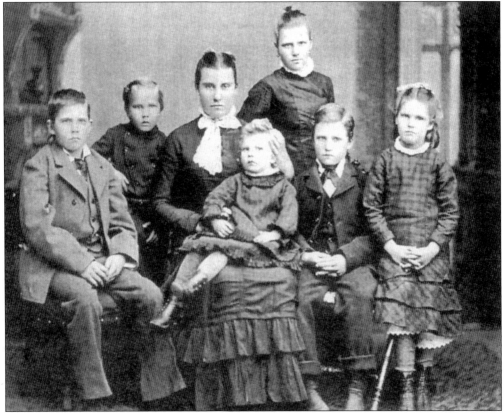

The Fickerts settled in Bear Valley with three children. Ultimately Mary would give birth to 10 children, 7 of whom survived. Pictured here in 1882, from left to right, are Frank, Frederick Alford, Louise (with Adaline on her lap), Mary A. (Nellie), Charles Marion, and Clara (Clare). Louise and Nellie would end up running the ranch. (Courtesy Rick and Donna Zucker, *The Cub.*)

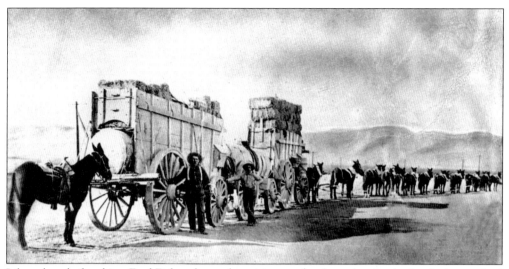

Like others before him, Fred Fickert began by raising cattle, then planting barley for hay to feed his stock during the winter. As more activity occurred along the Tehachapi Pass, there was a growing market for both hay and grain for the freight teams. Fickert had found his bonanza, not in nuggets of gold, but in kernels of grain. (Courtesy Kern County Museum.)

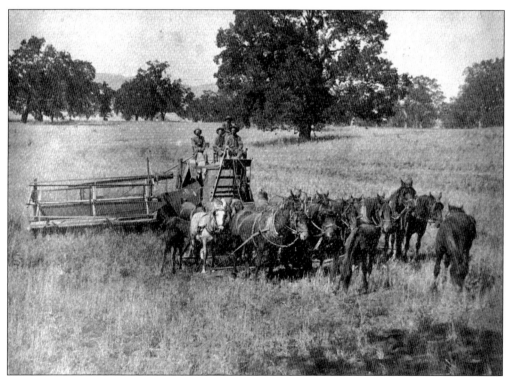

Asked to describe Bear Valley for the May 25, 1875, issue of *Southern Californian*, Fred Fickert wrote, "[It] contains about six sections of land, all occupied by families, and in a prosperous state of cultivation; 1230 acres in grain, barley over 400 pounds to the acre, wheat about the same. Some 300 acres of meadow covered with excellent wild clover yields 3 to 5 tons hay per acre." (Courtesy Tehachapi Heritage League.)

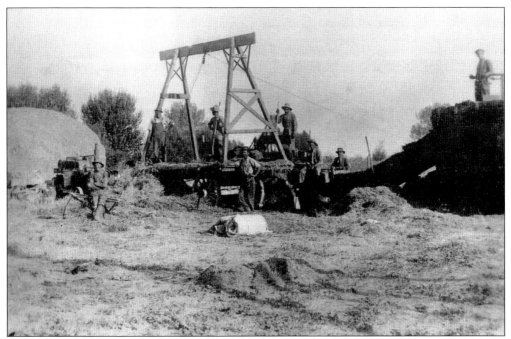

It took seven teams of horses to complete the first part of the haying process. Four were used on the mowers (which operated similar to hedge clippers) and three teams were hitched to the Jackson or sulky rake. The cut hay was first put into rows to dry, then raked into shocks six feet across and three feet high. (Courtesy Tehachapi Heritage League.)

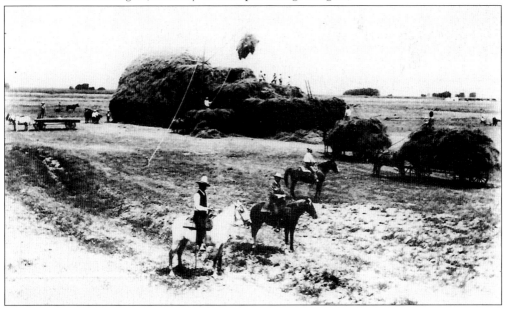

Harvest season was a community project. Ranchers pooled their manpower and moved from place to place until the harvest was complete. Women played a vital role since each ranch hosted the crews to breakfast, lunch, and dinner. The rule was "good-tasting, nourishing food and plenty of it." A ranch never lacked for willing workers when it had established a reputation for good food and generous servings! (Courtesy Kern County Museum.)

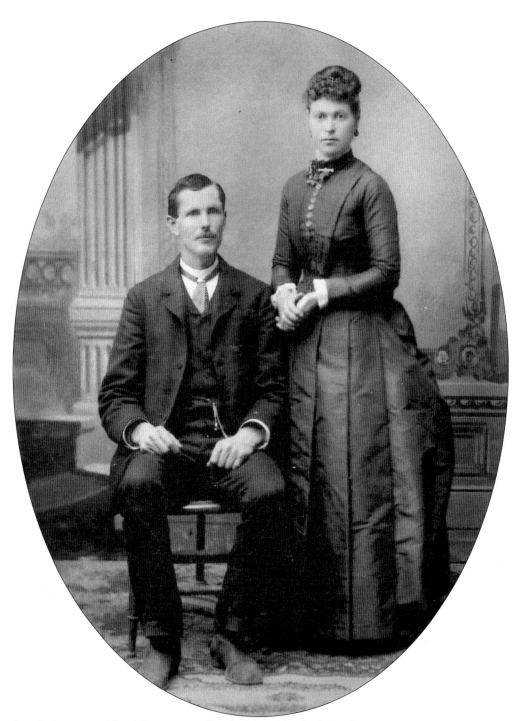

Joseph Benjamin (Sam) Fontaine and wife, Mary Elizabeth Cochrane Fontaine, pose prior to moving to Bear Valley. Their ranch occupied a portion of the land where the Oak Tree Country Club now stands. Young Mary Elizabeth was not prepared for the isolation or the cold winters, so when Fickert offered to pay off their account at Gallinger and Waterman's Mercantile in exchange for the deed to their ranch, they accepted. (Courtesy Fontaine family.)

After leaving Bear Valley Joseph and Mary Elizabeth Fontaine posed for this portrait with their three children. Pictured, from left to right, are Lena (b. 1896), William Randolph Hearst Fontaine (b. 1900), and Catherine (b. 1906). (Courtesy Fontaine family.)

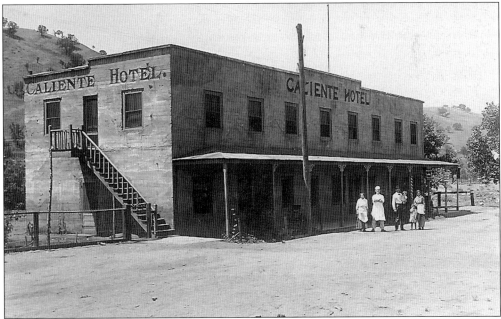

The Fontaines' next move was to Caliente, where they operated a grocery and this hotel until 1880. They are shown in front of the hotel. Joseph is holding William and daughter Lena is next to Mary, far right. The housekeeper and cook on the left are not identified by name. (Courtesy Fontaine family.)

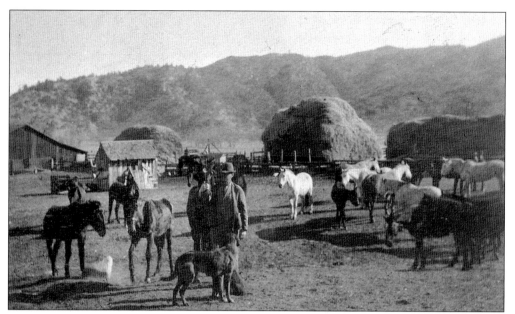

Ranchers pooled their resources during harvest season and roundups. Each ranch played host to the large crews so raising ample food was a necessity. Aside from the customary horses and cows, farm yards included chickens and geese, one or two sheep, and several hogs. Gardens included corn, squash, beans, cabbage, and peppers, plus one or two fruit trees. (Courtesy Tehachapi Heritage League.)

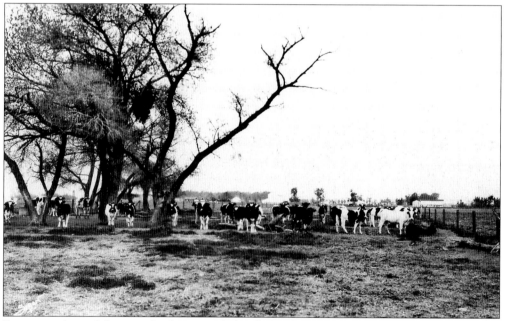

Farmers with good dairy stock often provided milk for those who brought their own containers. Within a few years, a new industry was added to the local economy—dairies. Mrs. Freeman sold milk in Old Town until she, and her cow, moved to the new Tehachapi. She was replaced by J. J. Phillips, who later sold to William Dickerson. William Kizer was sometimes referred to as the "Dairy King" of Brite Valley. (Courtesy Kern County Museum.)

In 1882, Ross Hill, who suffered from severe asthma, moved his family out of Los Angeles to live in Cummings Valley where he had purchased 334 acres. Ross died in 1904, and 16-year-old Roland took over the management of the ranch, assisted by his younger brother Russell. (Courtesy Tehachapi Heritage League.)

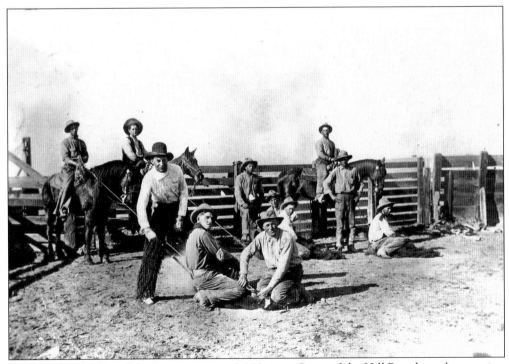

By 1890, the Hill Ranch had grown to over 2,000 acres. Some of the Hill Ranch cowboys posing for this scene while branding calves, from left to right, are (on horseback) Bill Chappell, Faye Adams, and Fayrel Chappell. Dan Chappell is holding the branding iron, while Duncan Monroe and Jim Glenn hold a calf. (Courtesy Tehachapi Heritage League.)

Every boy—and girl—learned to ride at an early age. Roland and Russell Hill became renowned for their horsemanship skills, which they had learned from the talented vaqueros of the nearby Tejon Ranch. (Courtesy Tehachapi Heritage League.)

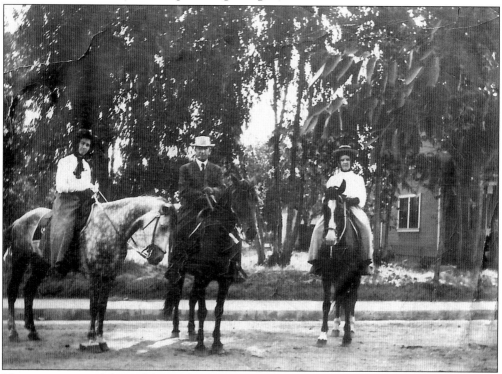

Horses were not solely used for work. This trio of young adults was among those who enjoyed riding for pleasure. Rare were the youngsters or adults who could not ride a horse. (Courtesy Tehachapi Heritage League.)

Youngsters, boys and girls alike, grew up around horses. A special treat for one not ready to "ride with the adults" was to climb aboard one of the sturdy work horses and ride it back to the barn after it had finished a day's work in the field. (Courtesy Tehachapi Heritage League.)

Roundups often became a family event. If one could sit on a horse, they could participate. Friends and visitors from town looked forward to being invited to ride along on a roundup, even it meant being stiff and sore afterwards. It was an experience to be long remembered. (Courtesy Tehachapi Heritage League.)

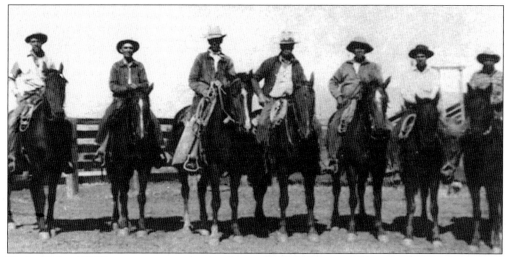

Under Roland Hill's management, the ranch grew to 14,000 acres and became known for its herd of purebred Morgan horses. Many considered themselves fortunate to ride for the outfit as Hill wanted only the best to ride for him. Anyone who showed excessive force on any horse was fired on the spot. (Courtesy Tehachapi Heritage League.)

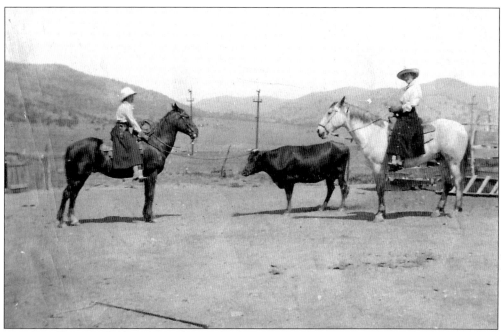

Myrtle Williamson (left) and Glenda Wright show that ranch work was not confined to just men; women could rope, ride, and manage a ranch. Louise and Mary (Nellie) Fickert's experiences proved invaluable when, following the death of their parents, they took over the management of the Fickert domain. John Cuddeback's daughter Alzada also continued to run her father's ranch until it was sold in the late 1930s. (Courtesy Tehachapi Heritage League.)

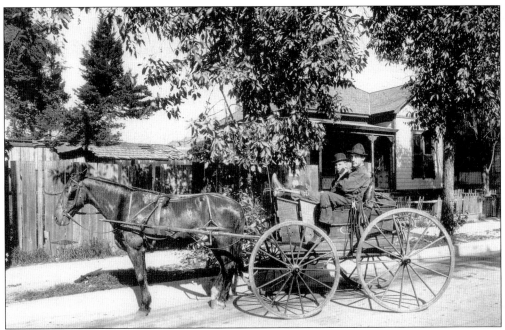

The preferred mode of travel, for some, was a horse and buggy. It was comfortable and less inclined to dirty one's attire when driving to church, a town meeting, or social. A young woman might be more inclined to say yes when her suitor proposed during a buggy ride on a moonlight night—especially if the horse and buggy were both clean and smart looking. (Courtesy Edison Historical collection.)

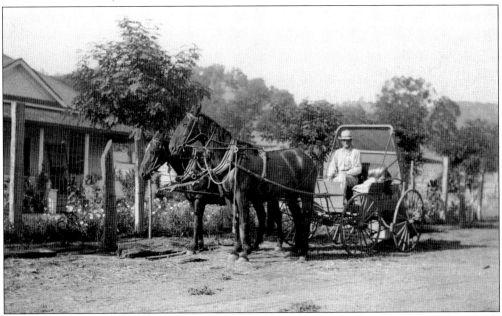

Driving a coach was a sign that one had reached a state of prosperity, and it became the vehicle of choice for one's beloved family. Of course an expensive vehicle demanded a team of special horses. Lucas Brite solved this problem by breeding elegant French Coach Horses. He was soon selling them to others. (Courtesy Tehachapi Heritage League.)

Lucas Brite had learned a great deal from his business savvy father, John. As ranchers planted more acreage in grain, there was an increased demand for good, stout draft horses. Lucas began breeding Percherons, which had first been imported to the United States from the La Perche province of France in 1840. The breed was both attractive and serviceable. It was also docile, making it an ideal family horse. (Courtesy Tehachapi Heritage League.)

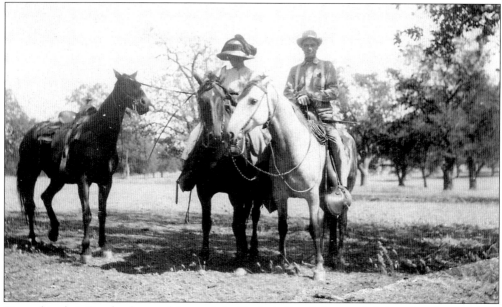

Dressed in their Sunday finery, this couple holds their friend's horse while he takes their picture. Although riding was as natural as walking for the majority of residents, this proved no immunity from accidents such as related in this *Kern Weekly Courier* newspaper article on January 1, 1873, "We learn of a distressing accident which occurred in Tehachapi on Sunday last. Miss Wiggins, a young lady of eighteen to twenty years was thrown from her horse on the way to church." (Courtesy Tehachapi Heritage League.)

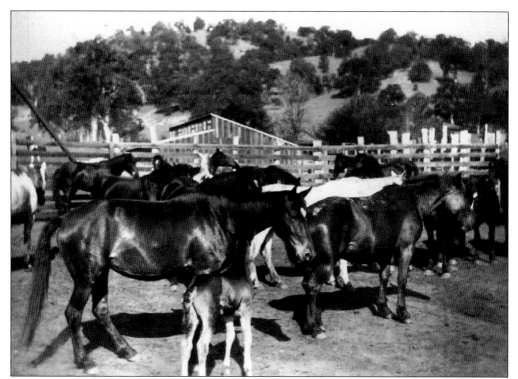

Ranchers, who provided three to eight horses per rider, found it more productive to raise their own horses. Depending upon the number of acres and type of terrain to be ridden, a cowboy was expected to change horses two to three times a day. This prevented an animal from becoming too exhausted. Ranchers who raised draft breeds could also make additional money by leasing them to others during the harvest season. (Courtesy Tehachapi Heritage League.)

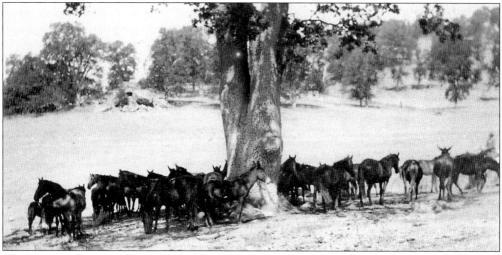

The Three Valleys soon became noted for raising fine horses. Unfortunately such notoriety was not always beneficial to the horse owner, for not everyone came to buy. In April 1865, the *Los Angeles News* reported, "Twenty-five armed men, many of them 'rebels from Price's army' drove off a herd of 200 horses from George Cummings ranch in Cummings Valley. Mr. Cummings is a strong Union man and the blow was especially aimed at him." (Courtesy Tehachapi Heritage League.)

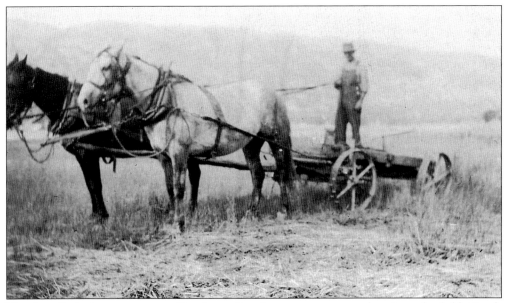

This low, flatbed wagon was used by the earliest farmers to carry cut hay from the field. Hand-wielded scythes with three-foot curved blades cut the stalks. Pitchforks were then used to form shocks, which were allowed to dry for three to four days They were then loaded onto this wagon and hauled to where men waited with pitchforks to pitch the loose hay into a stack. (Courtesy Tehachapi Heritage League.)

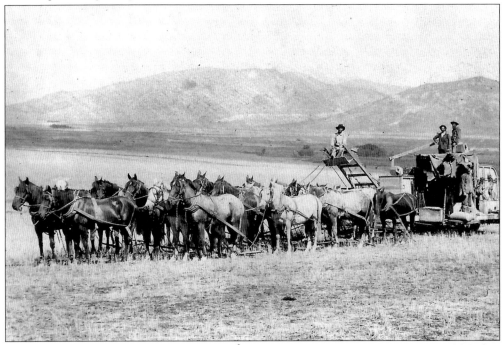

In 1892, Pete Bernamayou's ranch in Cummings Valley cut over 400 tons of hay, which sold for $12 a ton. The grain harvest netted 3,800 sacks of wheat and 2,600 sacks of barley from just 800 acres. All machinery was pulled by horses or mules—up to 22 in harness at one time. It was common for some 600 horses to be used during a harvest. (Courtesy Tehachapi Heritage League.)

Elijah Stowell constructed this frame house in Cummings Valley as a gift for his bride, earning it the nickname of "the house that love built." It is said that when young Elijah asked John Brite for permission to court his daughter Chloe, the crusty father replied, "What do you have to offer that she doesn't already have?" Stowell not only built this house but became one of the area's most prosperous farmers. (Courtesy Tehachapi Heritage League.)

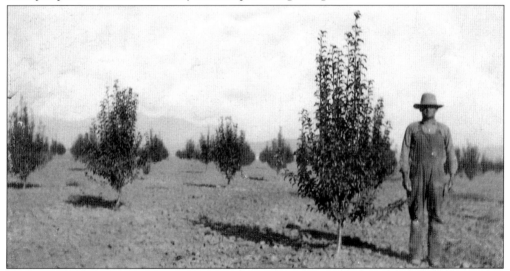

Elijah Stowell was industrious and innovative. In 1888, he was the first farmer to purchase the new mechanized reaper-thresher, which facilitated faster harvesting. In 1890, he then planted a small orchard of Bartlett pears. Four years later, the fruit was so prolific each tree had to have its limbs propped up to keep from breaking under the weight of the fruit. It was the beginning of a new orchard industry in the Three Valleys. (Courtesy Tehachapi Heritage League.)

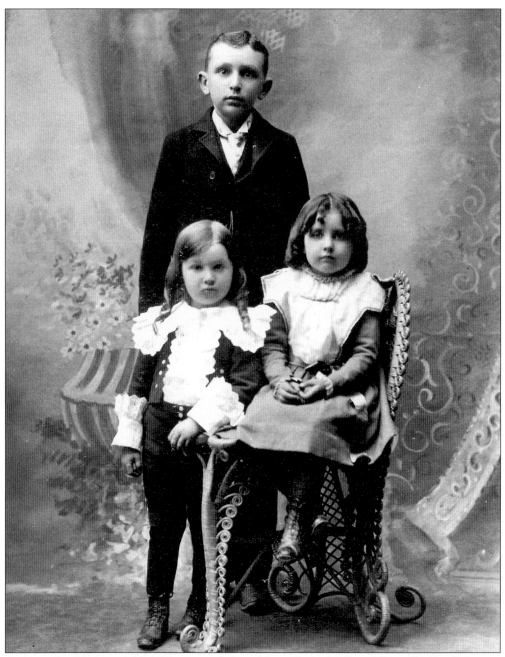

A young Jim Wiggins (in back) poses with his siblings Laura Holloway (on chair) and George Lester. Their father, William C. Wiggins, was the area's first schoolteacher. In 1861, the children of Brite Valley attended school in a one-room cabin John Brite had built on his ranch. William Wiggins was paid by the parents to teach school. (Courtesy Tehachapi Heritage League.)

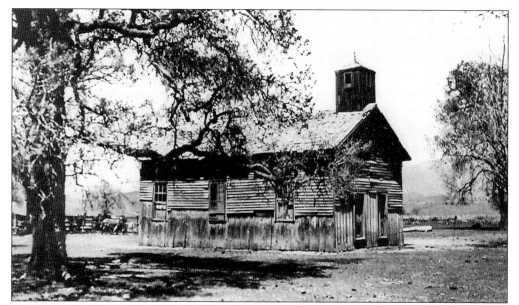

This Williamsburg School was the first schoolhouse within the newly formed Kern County. One of the first actions taken by the board of supervisors in 1866 was the formation of the Tehachapi School District. In 1867, residents built this school. It replaced the log cabin built by John Brite on his ranch where William Wiggins first taught the three R's. (Courtesy Kern County Museum.)

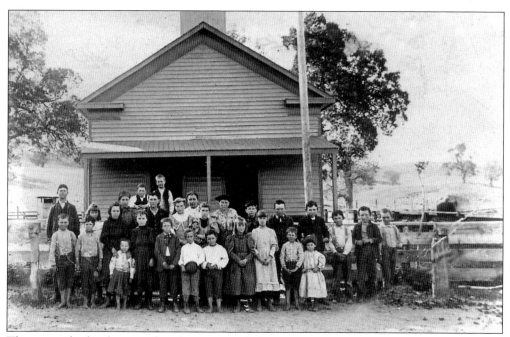

The original school was replaced in 1869 and, for a number of years, was Williamsburg's only remaining structure. Louisa May Jewett was the first teacher at the new school and the first woman teacher in Kern County. Her contract was for three months, but when residents discovered her salary would be paid by the county they talked her into staying for five. The ages of the students ran from 7 through 12 years. (Courtesy Tehachapi Heritage League.)

Bear Valley residents built this school following the formation of the Fitzgerald School District on May 7, 1872. It was the second school to be built in the area. There were no roads or lanes between the fenced boundaries of each ranch so students, who varied in age from seven to 15, had to open and close a number of gates coming to and going home from school. This, and severe winters, limited classes to the warmer weather. (Courtesy Bear Valley Schoolhouse Historical collection.)

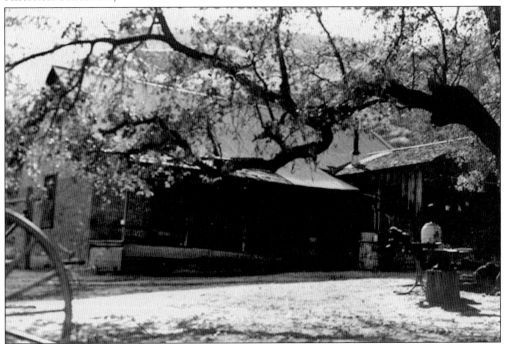

By 1899, Fred Fickert had bought out his neighbors, and the school enrollment dropped to three students. The Fitzgerald School District then became part of the Cummings Valley School District. In 1900, the Bear Valley Schoolhouse closed. Fickert then moved the structure to his ranch where it remained as a bunkhouse until the property was purchased by Dart Industries and moved to the Town Center. (Courtesy Tehachapi Heritage League.)

John Hickey, a native of Ireland, became a teacher, farmer, and itinerant preacher after arriving in the Three Valleys. For three years, he rode horseback from his farm in Cummings Valley to teach school in Bear Valley. At one time, he closed and locked the school following a dispute with a trustee. The school remained closed for some time until the two settled their differences and Hickey resumed classes. He later taught at the Cummings Valley School, then moved to Tehachapi where he became instrumental in incorporating the town and was elected as its first mayor. (Courtesy Tehachapi Heritage League.)

Identified only as Harold and Emmett, these two boys demonstrate one of the ways that youngsters of the 1800s enjoyed themselves. The handmade stilts could be used as tests of one's skill such as who had the highest stilts or who could walk the farthest without falling down. (Courtesy Tehachapi Heritage League.)

The Dick Williamson family was among those who would, on occasion, pile into a wagon along with blankets and baskets of cold chicken, ham or beef sandwiches, homemade cookies, and jars of lemonade for a day's outing. Dick came to the Tehachapi Valley in 1879, and after marrying a daughter of Mary Ann Haigh, moved to White Rock Creek. In 1905, he moved to Tehachapi and became a deputy marshal. (Courtesy Tehachapi Heritage League.)

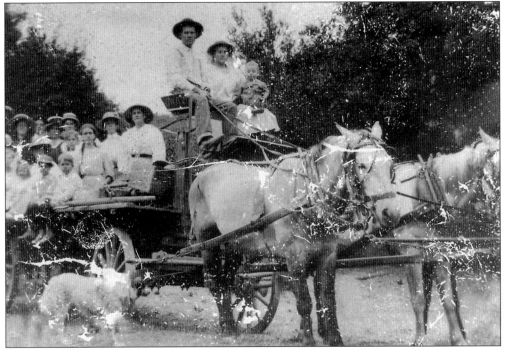

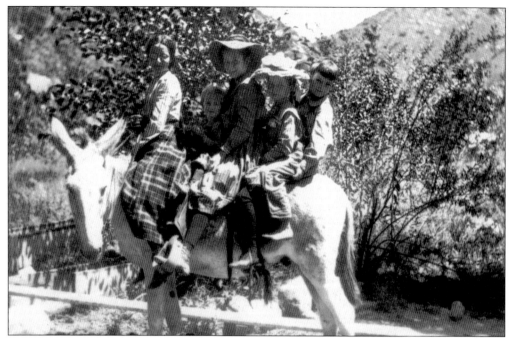

Burros were the patient babysitters of the 1800s and it was not too uncommon to see one burro with multiple passengers. One old-timer recalled he and his brother sometimes riding their burro to school so they wouldn't be late. Once there, they turned it loose to return home. "It sure saved a lot of walking plus not being late for school." (Courtesy Edison Historical collection.)

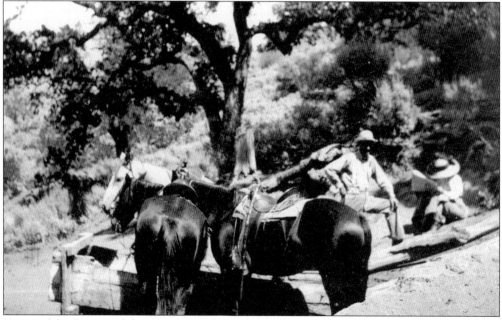

Young adults discovered that a picnic on the timbered slopes of Bear Mountain could be a romantic interlude, or should they encounter one of the numerous bears or mountain lions of the area, an experience fraught with danger. With "safety being in numbers," three to four couples would join forces for a horseback journey into the tall timber. (Courtesy Tehachapi Heritage League.)

Cards were the favored pastime for many who needed a break from the toils of their every day life. Whist, Monte, and Draw Poker were among the favorite games taking place at any given time in any one of Williamsburg's three saloons. (Courtesy Tehachapi Heritage League.)

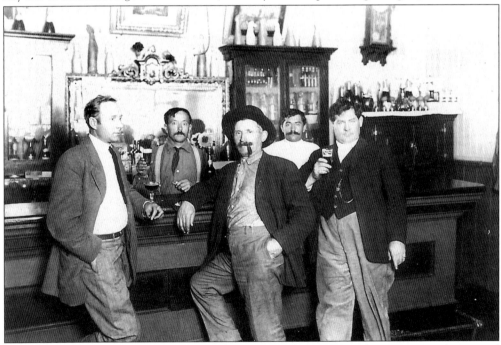

Saloons not only quenched the thirst, and sometimes the appetite of its customers, but served as a meeting place where men could make business deals or form partnerships. Harvey Spencer owned a saloon in Old Town, and also ran cattle in Bear Valley with his partner John Durnal. (Courtesy Kern County Museum.)

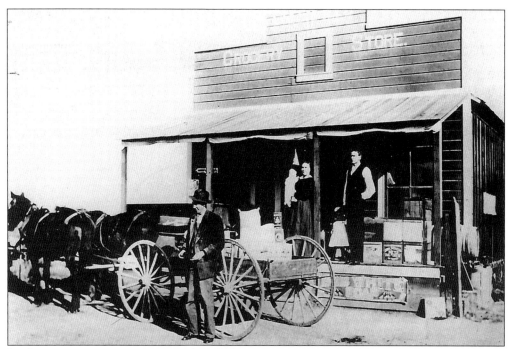

By the time a grocery store opened in Old Town, a customer could buy the latest in the new invention—canned foods. There was Van Camp's beans in tomato sauce (introduced during the mid 1860s), Heinz ketchup (1876), and Log Cabin syrup (1887) in tins resembling a log cabin. (Courtesy Kern County Museum.)

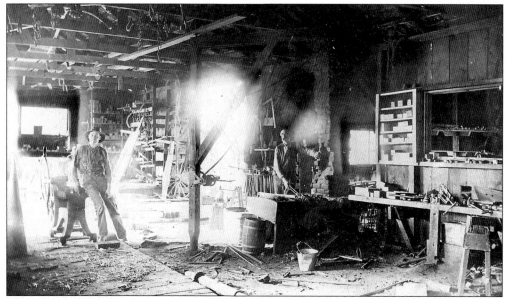

A blacksmith found ample work as he forged and shaped iron into such products as nails, shoes for horses and mules, tools, utensils, pots, pans, plowshares, and branding irons. He also made or repaired wheels for coaches, wagons, and carriages. During the Victorian era, a talented blacksmith created ornate weather vanes, fences, and grillwork for homes. (Courtesy Tehachapi Heritage League.)

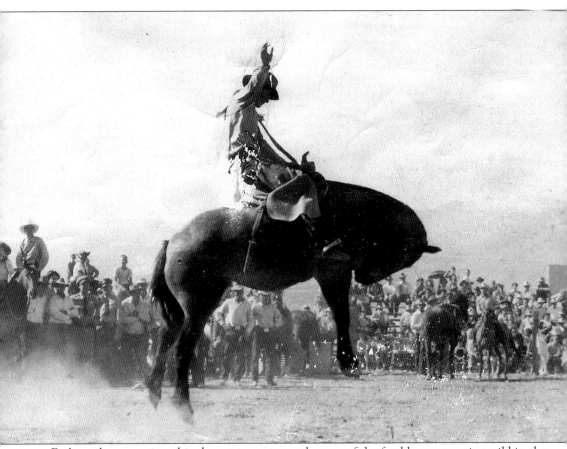

Early settlers sometimes hired mustangers to catch some of the feral horses running wild in the area. To break them to saddle, a professional bronc stomper would be hired at $5 to $10 a head. The process was simple—and rough. A horse would be roped by the forefeet and thrown to the ground where it would be blindfolded, saddled, and equipped with a bit-less bridle. Just as the blindfold was removed and the horse got to its feet, the rider was already in the saddle. A horse was considered "broken" when it no longer had to be thrown in order to be saddled. Hard riding did the remainder of the process. (Courtesy Tehachapi Heritage League.)

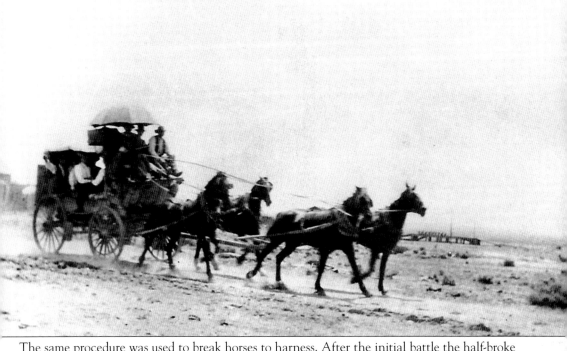

The same procedure was used to break horses to harness. After the initial battle the half-broke team would be hitched before a team of seasoned wheel horses who were expected to do the rest. Stage drivers had to deal with such nervous and inexperienced horses; keep the stage upright and still maintain a rigid schedule. Passengers were warned that a trip could be a bone-jarring experience and runaways were to be expected. Drivers who could keep their teams in check, and their passengers unhurt, were eulogized as "Knights of the Reins." (Courtesy Kern County Museum.)

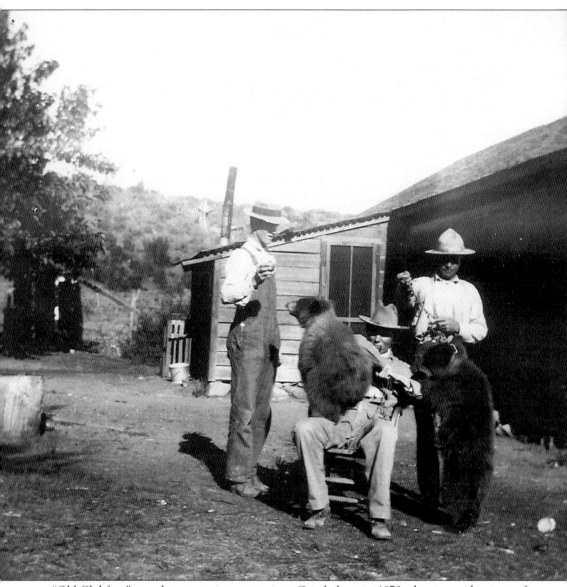

"Old Clubfoot" was the name given to a giant Grizzly bear in 1879 who was said to roam from his home on Bear Mountain to the ranges of San Bernardino and San Luis Obispo. Was it just one bear or several? No one knew for sure except all reported seeing a bear that was "big as an ox!" In 1890, Jerky Johnson (with a bear cub on his lap), a professional hunter, claimed to have shot and killed Old Clubfoot on Bear Mountain. The massive bear weighed 1,100 pounds and was put on display in Bakersfield where people paid an admission fee to see the carcass. Whether or not the Grizzly was actually Old Clubfoot was never officially determined. However, from that date on, there were no further reported sightings of the legendary bruin. (Courtesy Kern County Museum.)

Four

THE GRAND CIRCUIT

Many ranchers raised sheep, but it wasn't until 1860 that the sheep industry began to flourish. That's when Solomon W. Jewett of Bakersfield imported a band of fine-wooled Merino sheep from Vermont. The sheep adapted well to their new environment in the San Joaquin Valley. So did many Basque herders, who found that the nearby Tehachapi Mountains reminded them of their Pyrennes homeland.

Sheep ranchers soon discovered there was an abundance of year-round feed if they utilized both the mountains and the deserts. They accomplished this by slowly moving their flocks through the Tehachapis, into the desert, then back through the Sierras and home. The sheep grazed as they traveled the 600-mile route, which took 10 months to complete. It was called the Grand Circuit and herders often used a variety of routes to reach the mountain pasture lands. But the favored of many was the trail that went through Cummings Valley, then east into the desert. They called this route the Tehachapi Driveway."

The circuit continued for several decades until much of the land became fenced off. The long drives were over, but some sheep men continued the tradition by leasing choice grazing parcels and transporting their flocks by truck. Some herders still maintain this tradition each Spring as a reminder of when the Tehachapi Driveway was part of the Grand Circuit.

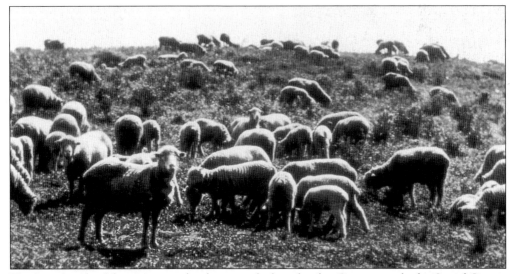

The large bands of sheep were under the control of one herder. Consequently the Grand Circuit required men of great physical and mental stamina who were able to handle any emergency in all kinds of weather. As young boys, many had served their apprenticeships in the Pyrennes Mountains and felt at home in the meadows of the Tehachapis and the Sierra Nevada. (Courtesy Tejon Ranch Company.)

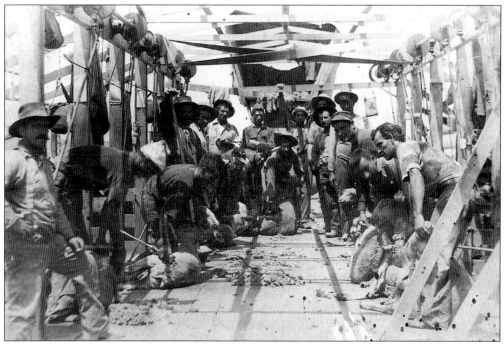

Before making the Grand Circuit, sheep were first sheared of their heavy winter coat in order to make the long drive without the extra weight. The drive, with 2,000 to 2,500 sheep, began each spring after they had wintered at the home ranch. (Courtesy Kern County Museum.)

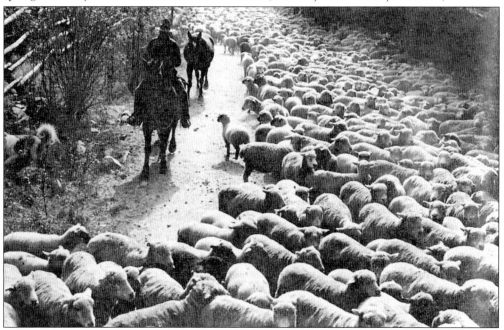

Sheep owners depended upon herders trustworthy and competent enough to handle the responsibility of thousands of sheep. During the long trek, they encountered all kinds of weather and a variety of terrain, which often was infested with the natural enemies of sheep such as eagles, wolves, coyotes, mountain lions, and bears. (Courtesy U.S. Department of Agriculture.)

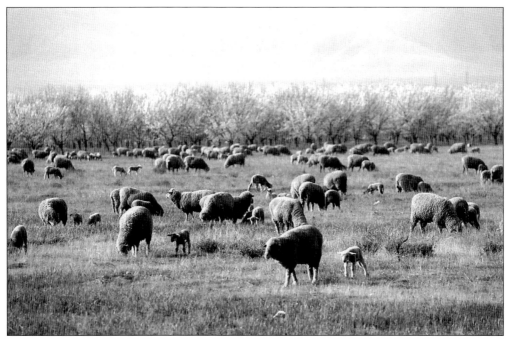

Lambing season coincided with the start of the Grand Circuit. The lush grasses of early spring helped ewes produce an ample supply of the rich milk the growing lambs needed for good health and stamina on the long journey. (Courtesy Tejon Ranch Company.)

Bummer lambs was the name given to newly born lambs who had become orphaned or had been born as a twin. They were considered too weak to make the long journey and were given to families along the route. Youngsters, such as three-year old Shirley Etchecopar, eagerly assumed the task of feeding the orphans. (Courtesy Tehachapi Heritage League.)

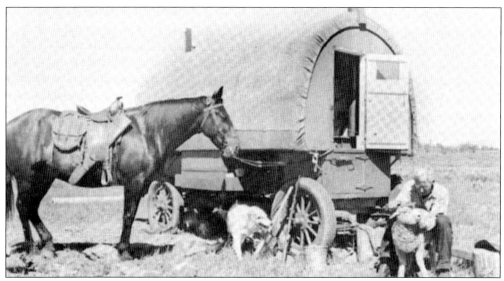

The herder led a lonely, nomadic life. The drive took 10 months of his life away from family and friends. His only companions on the 600-mile journey were his sheep, his dogs, and his saddle horse. (Courtesy U.S. Department of Agriculture.)

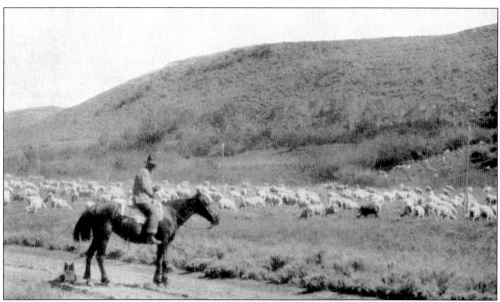

The Tehachapi Driveway started in the San Joaquin Valley at Comanche Point and continued over the mountains into Cummings and Bear Valleys. The trail became known as the Sheep Trail and for many years, residents used it to travel into the San Joaquin Valley. Today it is known as Comanche Point Road and, since it is not regularly maintained, requires a four-wheel drive for travel. (Courtesy U.S. Department of Agriculture.)

Five

CALIENTE

No history of the Three Valleys of Tehachapi would be complete without including Caliente. Located some 16 miles (as the bird flies) west of Tehachapi, it lies in a small valley surrounded by the high mountains of the Tehachapi Pass.

Prior to 1869, it was just a cow camp belonging to rancher George Allen. But that was the year Southern Pacific Railroad began construction of a north to south line, connecting the Bay Area with Los Angeles. It was a project that would make significant changes in the area. Rail officials purchased Allen's property and renamed it Caliente, Spanish for "hot;" a name that may have applied to the climate, but could also have prophesied its future as a "hot bed" of activity.

As the rail crews steadily moved south, interest in Caliente's future grew. *The Havilah Miner* predicted the area would be "the liveliest place in Kern County." They were correct. In April 1875, the first train pulled into Caliente. By autumn, there were over 2,000 construction workers mingling with teamsters, miners, cowboys, business travelers, and gamblers in a town that boasted more saloons than houses. The railroad's $100,000 monthly payroll attracted a number of desperadoes and Caliente soon earned the dubious title of "another hellhole of the west." But nature would have the final say.

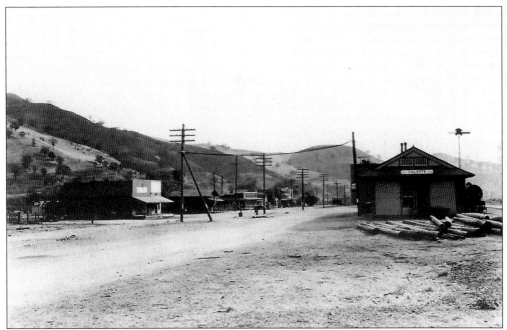

In 1875, Caliente's population numbered more than 3,000. There were four general stores, four barbershops, three hotels, and 20 saloons. Reme Nadeau made it headquarters for his $500,000 Cerro Gordo Freighting Company and built offices, stables, corrals, a blacksmith and harness shop, and a feed room that included a steam-driven feed grinder. Everyone agreed it would become a major California city. (Courtesy Kern County Museum.)

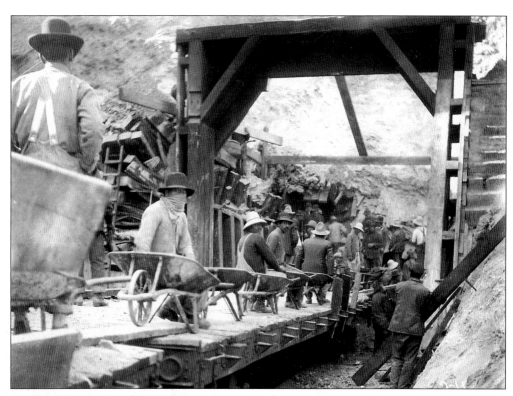

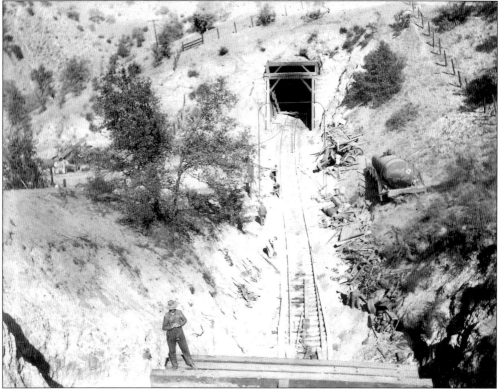

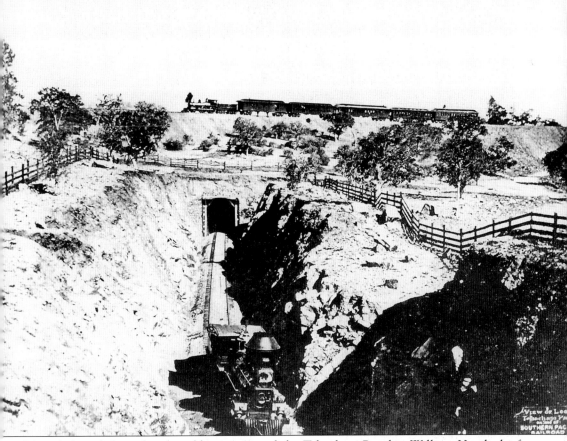

Many believed the railroad could never ascend the Tehachapi Pass but William Hood, chief engineer for the Southern Pacific, proved them wrong. Starting from the summit he surveyed downward, following the curves and contours of the terrain. This resulted in the creation of the Tehachapi Loop, a circular track on which a train actually passes above and below itself at the same time. (Courtesy Kern County Museum.)

OPPOSITE, ABOVE: Over 2,500 men using hand tools and mule power had, within a year's time, conquered the 4,000 foot high Tehachapi Pass. Six hundred kegs of Hercules powder were used per week on the granite walls of Bear Mountain to create a roadbed with 18 tunnels, 22 feet high and 16.5 feet wide. Each tunnel was shored with 11 by 14 timbers imported from the redwood forests of Mendocino as were the railroad ties—2,800 to the mile. (Courtesy Tehachapi Heritage League.)

OPPOSITE, BELOW: The Southern Pacific hired 1,000 Chinese laborers to work on the Tehachapi Pass. In order to set and light the dynamite charges on the sheer rock walls of Bear Mountain, the laborers were lowered in baskets, then hastily pulled back to safety. Over 300 Chinese were killed in explosions and tunnel cave-ins. They were buried near Caliente until their bodies could be exhumed and returned to China. (Courtesy Tehachapi Heritage League.)

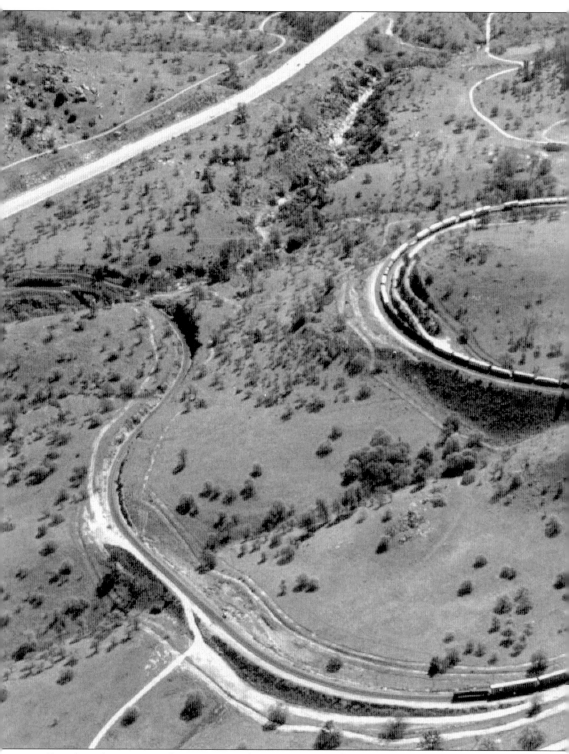

Based on the premise of two giant circles, a train not only crosses above and below but around itself. Originally constructed in 1875–1876, it remains a engineering marvel for railroad buffs the

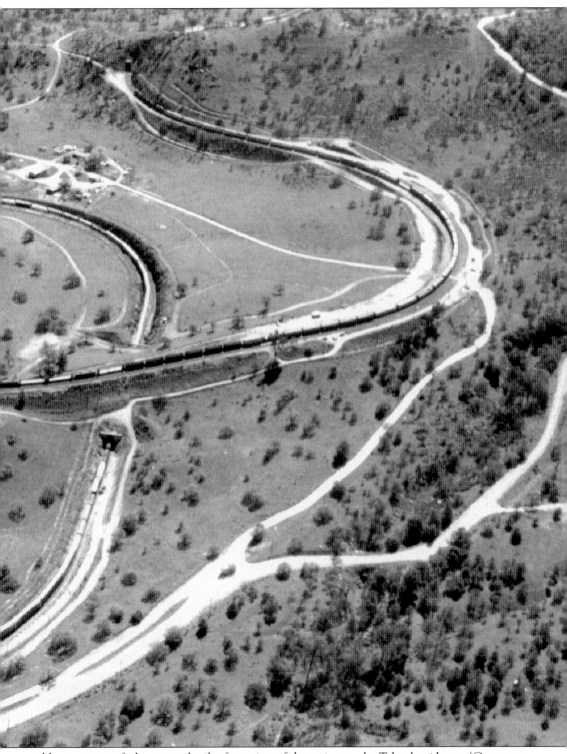

world over, many of whom travel miles for a view of the trains on the Tehachapi Loop. (Courtesy Tehachapi Heritage League.)

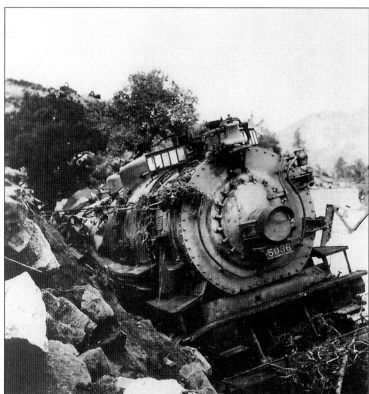

Beginning in 1888, Caliente was hit with a series of disastrous floods, which swept away much of the town. But by far the most devastating one occurred in September 1932 when the area was hit with a series of late tropical storms. The earth became so saturated, it crumbled beneath several miles of tracks and took this locomotive with it. (Courtesy Kern County Museum.)

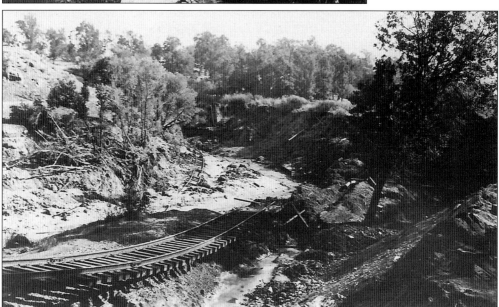

On September 30, 1932, Tehachapi Creek became a raging torrent. By the time it reached railroad crossing No. 7, it had gathered enough mud and debris to create a small dam. Under continual pressure, this soon gave way. Water roared downward at 30,000 cubic feet per second. By the time it reached Caliente, the flood had increased to 37,000 cubic feet per second. All railroad crossings and 31 miles of track were destroyed. (Courtesy Kern County Museum.)

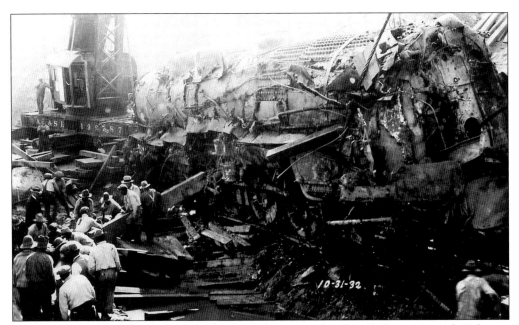

A churning, muddy, debris-laden Tehachapi Creek continued its downhill surge towards Caliente. In its path was this AT&SF engine. The powerful rush of water carried it along. It was not found until two weeks later, some 150 feet downstream, buried under 15 feet of mud. Its headlight and bell were never recovered. (Courtesy Kern County Museum.)

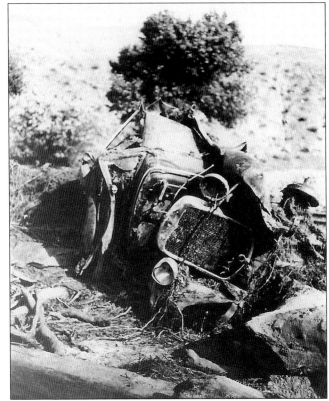

The raging flood waters did not confine themselves to the railroad. Buildings, cars, and humans were also victims. Some 75 people were listed as dead or missing. There was no definite tally as to the financial losses suffered except for the railroad's estimated $500,000 in damages, plus several weeks out of service. (Courtesy Kern County Museum.)

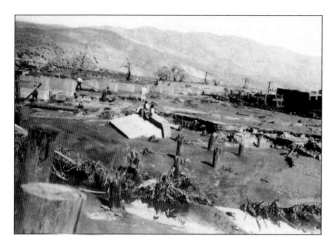

Caliente's first major catastrophe occurred in 1909 when stored dynamite exploded and caused a fire that destroyed much of the town. Four years later, Caliente Creek flooded and washed away many of the remaining buildings. More flooding followed in 1932. In 1983, the sleepy Caliente Creek suddenly erupted into a raging torrent that washed away several miles of railroad tracks and stopped service for several weeks. (Courtesy Kern County Museum.)

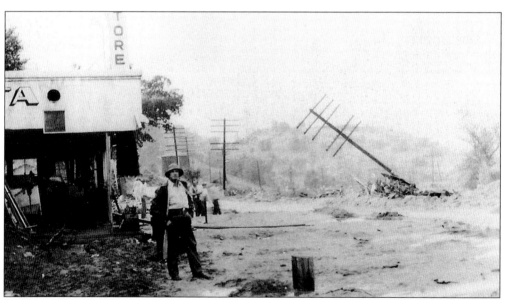

Keene is located in the Tehachapi Pass, a few miles east of Caliente. It was previously known as Wells Station and also Woodford. In 1945, after several days of heavy rain, Tehachapi Creek once again flooded and boiled into Keene. The El Rita Cafe was in its path. When it was over, much of the cafe was gone and three people were dead. (Courtesy Tehachapi Heritage League.)

Six

THE 20TH CENTURY

As the nation entered a new century, most eastern states were already in the early stages of industrialization. Factories were kept busy mass producing items designed to minimize the work load while increasing productivity. Thomas Edison's method of harnessing electricity was gradually replacing kerosene lanterns.

Local farmers were among those who looked forward to trying different crops and new equipment as fast as manufacturers turned them out. Businessmen and housewives soon wanted anything that would make their work more efficient. Henry Ford's 1906 production line made the Model T more affordable, and tractors soon followed. Mail order catalogs provided even the most isolated household with the opportunity to order the latest in sewing machines, cook stoves, washing machines, and the newly invented cream separator. Such time savers now provided families the opportunity to socialize, form discussion groups, and join civic organizations.

By the late 1900s, the residents of the Three Valleys had kept up with the new era. They had weathered the Great Depression, two World Wars, several armed conflicts, and a fluctuating market for their products. Even nature, with its disastrous droughts, floods, and earthquakes, failed to stop the progress.

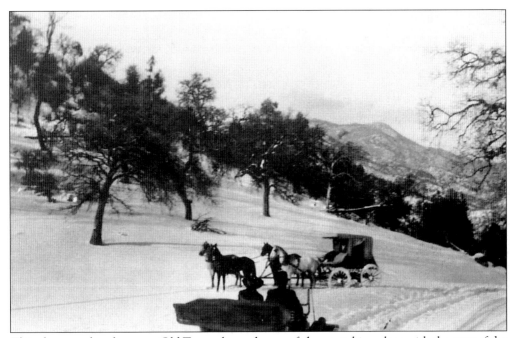

This photograph, taken near Old Town, shows the era of change taking place with the start of the 1900s. Horses were still the most common means of transportation whether for work or pleasure. Automobiles were an oddity and not yet accepted by the majority of the populace. By the end of the century, these roles would be reversed. (Courtesy Kern County Museum.)

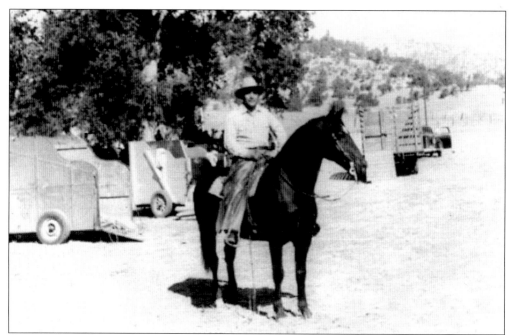

Antonio Leiva first saw Cummings Valley while driving a herd of horses from California to Utah. In 1880, he returned with a wife and their firstborn. He quickly found work with the Cummings, Hill, and Tejon ranches and later became cattle boss for the Tejon, a position he held for 30 years. He died at age 84 in his home in Tehachapi after being ill for just one week. (Courtesy Tehachapi Heritage League.)

Many a vaquero from the Three Valleys unrolled his bedroll inside this bunkhouse at the nearby Tejon Ranch. Out of Antonio Leiva's seven children, four of his sons would also work here—Roque (Rocky) rode until retiring in 1947, Armano (Jack) left in 1922 to open a gas station, Theodoro (Doro), and Jose (Joe) continued in the cattle business. (Courtesy Tejon Ranch Company.)

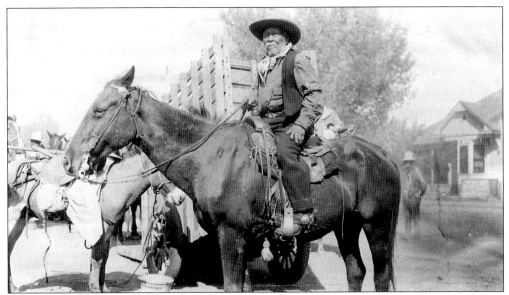

When this photograph was taken in 1940, Albalino Martinez was 101 years old and still a vaquero. He rode horses until he died at age 115. In his earlier years, Albalino was said to have been a courier for Tiburcio Vasquez, bringing ammunition and supplies to the bandit who was hiding in the Tehachapi Mountains. (Courtesy Tehachapi Heritage League.)

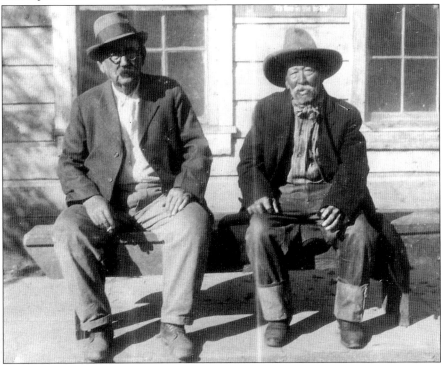

Albalino Martinez and Bob Glenn are in a quiet mood as they recall the many Bear and Cummings Valleys roundups they had participated in. Albalino rode for both the Tejon and Cummings ranches; Bob, and his brother Jerry, ran cattle with their registered brand in Bear Valley. (Courtesy Tehachapi Heritage League.)

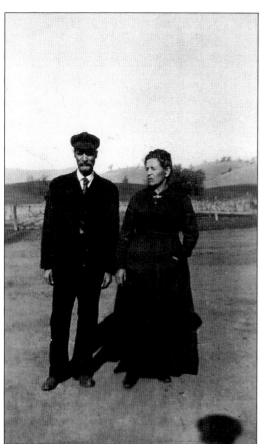

In 1890, Angelo and Jane Banducci first leased a ranch in Bear Valley and began raising wheat. Within 10 years they were able to buy a ranch in Cummings Valley. Since there were no local doctors, Jane's skills as an experienced midwife were much in demand by local families. (Courtesy Tehachapi Heritage League.)

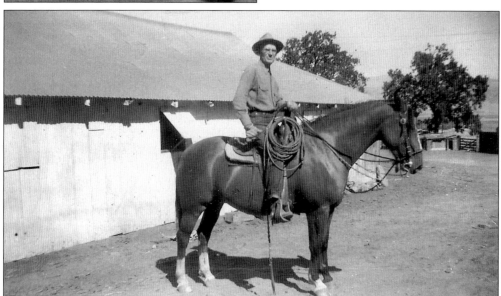

In 1893, Joe Banducci was born in Bear Valley to Angelo and Jane Banducci. He lived all his life in the area and died at the age of 88 years on September 26, 1981. An excellent horseman, he is shown here on his favorite horse Baldy. (Courtesy Tehachapi Heritage League.)

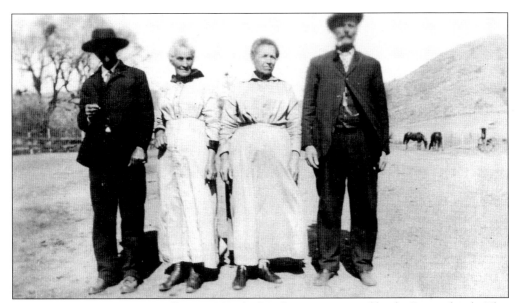

After moving to Cummings Valley in 1900, the Banduccis were joined by the Perreir family. This photograph taken in 1917 shows, from left to right, Frank Perreir, Antonio Perreir, Jane Banducci, and Angelo Banducci. (Courtesy Tehachapi Heritage League.)

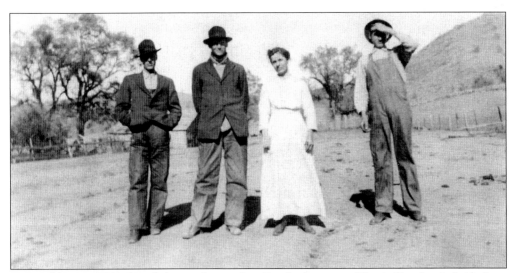

Pictured here in 1914, from left to right, are Joe, Frank, Annie, and Louie Banducci. Aside from farming and raising livestock, the Banduccis also engaged in making charcoal. The charcoal was bagged and delivered to the train depot in Tehachapi where it was shipped to an eager market in Los Angeles. (Courtesy Tehachapi Heritage League.)

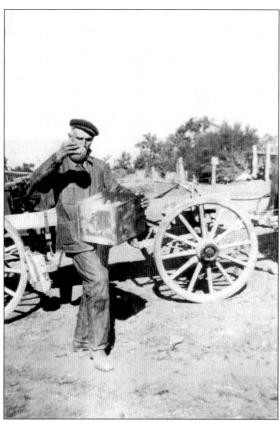

Although automobiles were becoming popular, some, like Frank Perreir shown in this 1920s photograph, still used horse-drawn wagons to bring supplies to their ranches in Cummings Valley. (Courtesy Tehachapi Heritage League.)

Whether it was habit or lack of money needed to buy the newer, more modernized equipment, many ranchers still used horses for plowing as shown by this early 1900s photograph taken in Bear Valley. (Courtesy Tehachapi Heritage League.)

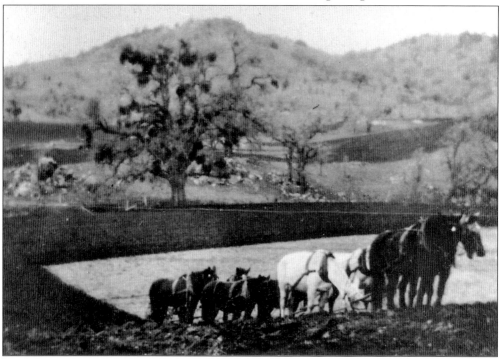

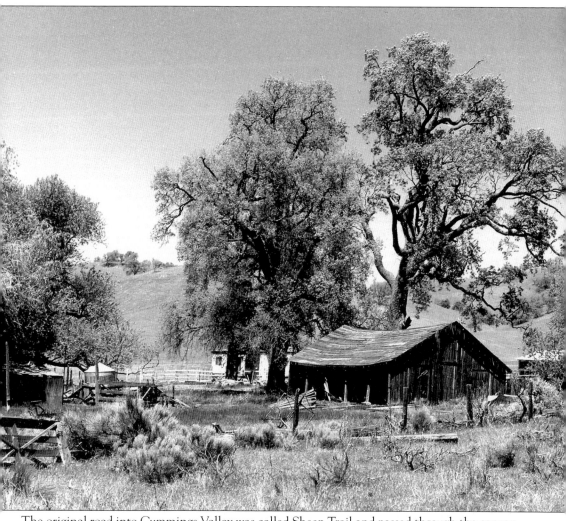

The original road into Cummings Valley was called Sheep Trail and passed through the canyon where the Moulet family had their ranch. In 1900, Antonio Banducci purchased Moulet's property and for many years travelers would pass by this carriage house at the heart of the ranch. Decades later, with increasing travel, the county took over all major roads in the area. They subsequently closed this one and constructed a new road that ran south of and above the ranch. They named it Banducci Road. (Courtesy Tehachapi Heritage League.)

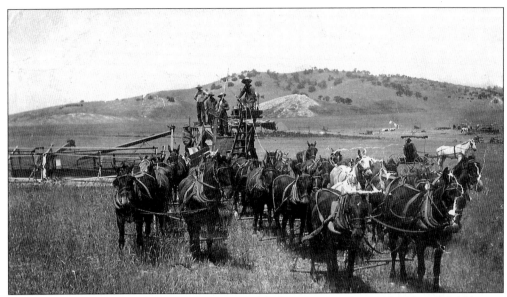

At the start of 1900, farming was still dominated by horse-power. Some 90,000 to 100,000 acres were planted in wheat and barley. Fourteen combined harvesters and 25 headers with a 12 to 16 foot sweep worked the fields. A total of 26 to 30 horses were required to pull each harvester with four to six horses for each header. (Courtesy Tehachapi Heritage League.)

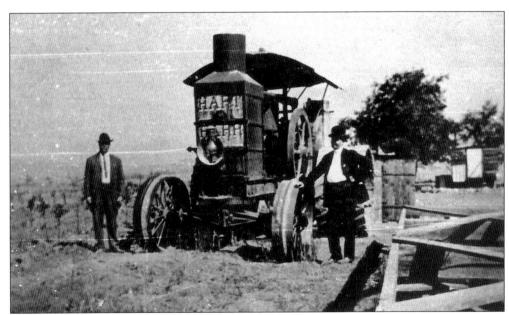

Change, however, did occur in farming techniques and in so doing, presented new challenges. Men, once skilled in driving large teams of horses, now had to learn how to handle the valves and levers that produced the steam needed to propel the new big and heavy "flamdangled" equipment. (Courtesy Tehachapi Heritage League.)

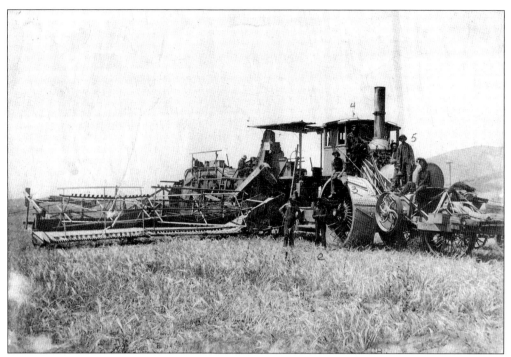

Steam-driven equipment soon cut down on manual labor Previously men with pitchforks and horse-drawn wagons transported newly cut hay to the barnyard where it was manually formed into a stack. But the new tractors now compressed the hay into bales that could be stored in stacks consisting of several tons. Many claimed the bales were easier to handle. (Courtesy Tehachapi Heritage League.)

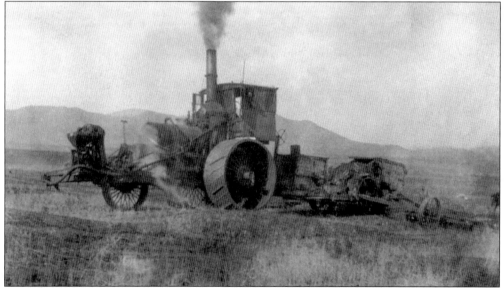

Gradually gasoline became the fuel used to power all equipment, making farming more efficient. No longer was time spent in feeding and harnessing the work teams, then reversing the process at the end of the day. A tractor could also be left in the middle of a field overnight to be fired up and used the next day. (Courtesy Tehachapi Heritage League.)

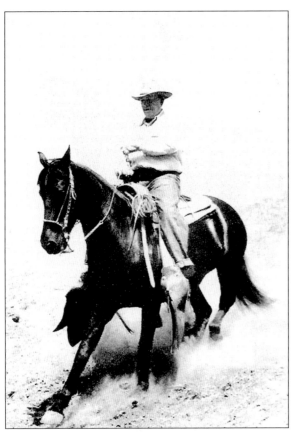

When Ross Hill died in 1904, 16-year-old Roland Hill, and his younger brother Russell, took control of the Hill Ranch. Roland was an efficient manager and increased the ranch from 2,000 to 14,000 acres. An excellent horseman, he imported purebred Morgan horses and would eventually be instrumental in the formation of the Morgan Horse Club. He later became a horse show judge. (Courtesy National Museum of the Morgan Horse.)

By far the most important purchase Hill made was that of this Morgan stallion. Because of the horse's gentle nature, he named it Querido, (Spanish for sweetheart). Querido became a top notch stock horse, a trait that he passed along to his sons and daughters. Querido sired 151 foals, which became the bulk of Hill's foundation stock. (Courtesy National Museum of the Morgan Horse.)

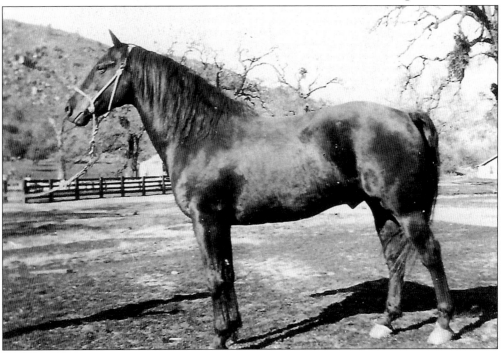

Jean Hill is seen on Sonfield. In 1914, the Hills went into partnership with the Gates Brothers, who later suffered great losses during the Wall Street crash. The ranch was sold, but Roland was retained as manager. He continued raising Morgan horses. Upon Roland's death in 1955, his wife, Ethel, and daughter Jean carried on the tradition of the Hill Morgans. (Courtesy National Museum of the Morgan Horse.)

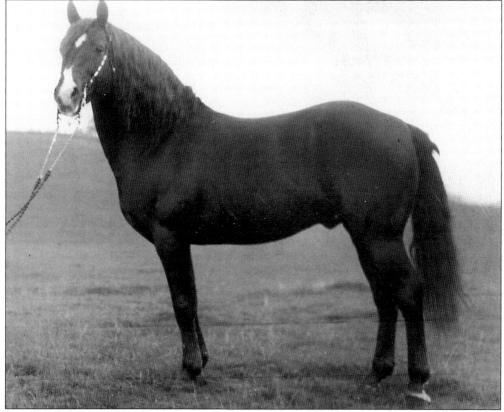

Sonfield was the second stallion to make an impressive addition to the Hill's breeding program. He was featured as a top-using cowhorse in the pages of *Western Livestock Journal* and *Western Horseman*, which had his picture on the cover of their May 1940 issue. His foals, from daughters of Querido, were in high demand as the ideal stock horse. (Courtesy National Museum of the Morgan Horse.)

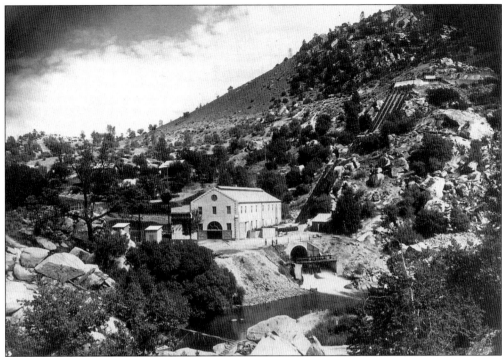

In 1904, Edison Electric built this Borel hydro plant on the Kern River. The 126-mile wood pole line carried 60,000 volts along the former Havilah to Los Angeles stage route and, for a brief time, was the world's longest transmission line. But electric power did not come to the Tehachapis until 1915 and then only on a limited basis. It did not include the Three Valleys. (Courtesy Edison Historical collection.)

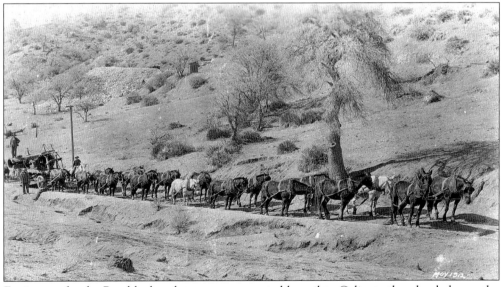

Equipment for the Borel hydro plant was transported by rail to Caliente then hauled over the rugged terrain to the Kern River. Local teamsters, skilled in handling a jerk line of 20 or more mules, were among those employed to transfer the bulky equipment to the construction site. (Courtesy Edison Historical collection.)

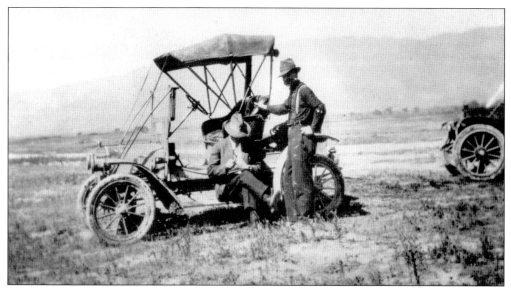

H. N. Siegfried (seated with map), chief engineer for Edison Electric, and his driver covered many miles to survey the scattered populace for their interest in buying electric power. By 1928, many farmers of the Three Valleys installed their own generators until such a service could be provided. (Courtesy Edison Historical collection.)

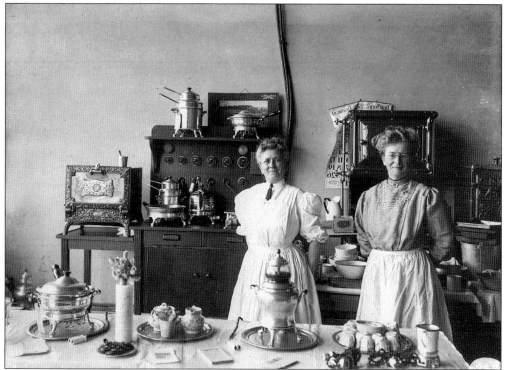

Cooking with electricity was a new challenge to those used to wood-burning or kerosene-fueled stoves. To help show the benefits of an electric stove, Edison Electric employed General Electric's Mrs. Colby (left) and an assistant to conduct free cooking demonstrations. (Courtesy Edison Historical collection.)

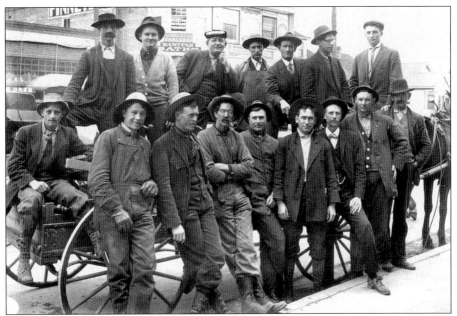

These Edison work crews originally had to travel by horse-drawn wagons to set poles and string lines, but the introduction of gasoline powered vehicles changed all that. The time spent traveling between projects was shortened considerably and allowed the work to progress much faster. (Courtesy Edison Historical collection.)

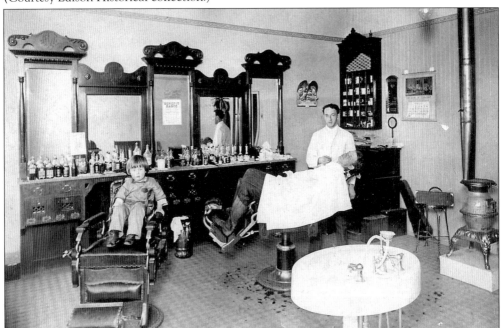

In the 1900s, the barbershop served the tonsorial needs of the male populace. The vogue was now a clean shaven look and shorter hair with a part in the middle. Younger men liked sideburns and mustaches and many opted for the "little" mustache, waxed and turned up at the ends. Older men wore huge, drooping "walrus" mustaches and mutton chop, or pointed chin beards. (Courtesy Tehachapi Heritage League.)

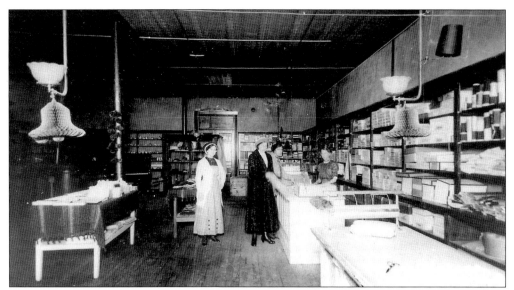

The paper bells suspended from light fixtures indicate this store is preparing for the Christmas shopper. The shelves are well stocked and the glass display cases filled with the latest fashions for men, women, and children. Shoppers would find shoes and silk stockings, shawls and ties, yards of imported laces and trim, and bolts of cloth from American gingham to silk Pongee from China. (Courtesy Tehachapi Heritage League.)

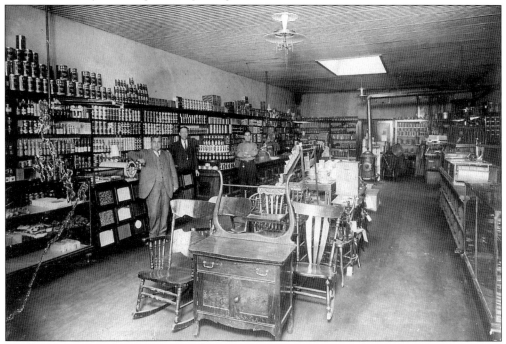

The local general store carried a broad variety of goods. On the left are shelves well stocked with a varied selection of canned goods, bottled condiments, and beverages. Flour, sugar, and legumes are displayed in bins with glass fronts. Dinnerware and furniture comprise the middle row, and hardware supplies are on the left. The customary wood stove and visitor chairs are in the back. (Courtesy Tehachapi Heritage League.)

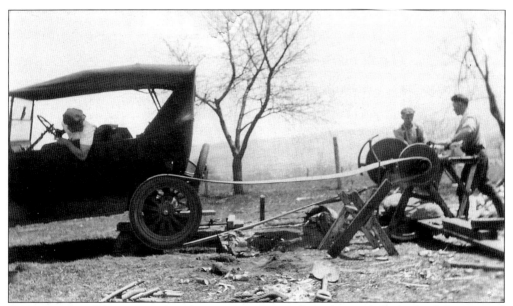

Cars proved useful in ways other than transportation. By jacking up the back of this car and replacing a rear wheel with a fan belt attached to a saw these men now had a "power saw." Several cords of firewood could be cut in far less time than it took when using the old handheld whipsaw. (Courtesy Tehachapi Heritage League.)

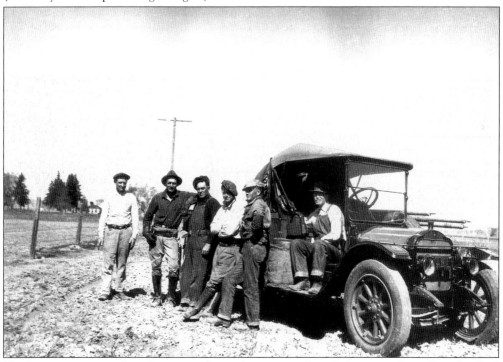

Trucks now transported produce to market and men to work in far less time than when they had to rely upon horse-drawn wagons. The time saving vehicles, however, did not please everyone. One old-timer complained that men had become "slackers" who looked forward to the ride instead of the work to be done. (Courtesy Edison Historical collection.)

By the 1920s, there was time for more socializing. Pictured here, from left to right, are Grace Errea, Nora Blair Brite, unidentified, "Dude" Chitwood, Grace Yorba, and Martha Erkel Watt. The young lady on the far right is not identified. (Courtesy Tehachapi Heritage League.)

"You push . . . I'll pull." Automobiles were now common enough to be the subject of several gag photographs staged by local young adults. Photograph albums held many pictures of automobiles with family members, along with an assortment of family pets. (Courtesy Tehachapi Heritage League.)

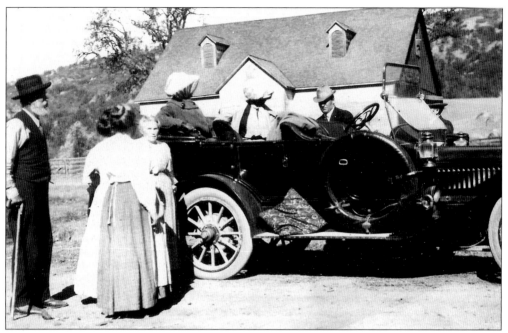

Fred Fickert (left) and his wife, Mary, surround their daughters Louise and Nellie as they say farewell to family members Charles and Clara after a 1910 visit. Fred Fickert bought his first car, a Winton, in 1909 and finally settled on Fords. After his death in 1938, Nellie took over driving the family car. Her sister Louise never learned how to drive. (Courtesy Tehachapi Heritage League.)

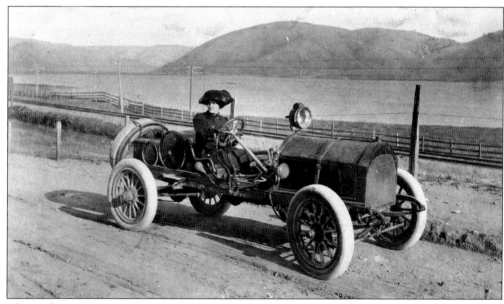

This early sports car was a most prestigious vehicle to own, and drive, especially for a woman. During the 1928 Prohibition, some claimed that a local farmer, making bootleg whiskey in a nearby canyon, got his booze past eagle-eyed authorities by using an attractive young lady driving her snazzy car. Along with her charming smile and a feminine wave, the officers would forget the tip that she was running hooch. (Courtesy Tehachapi Heritage League.)

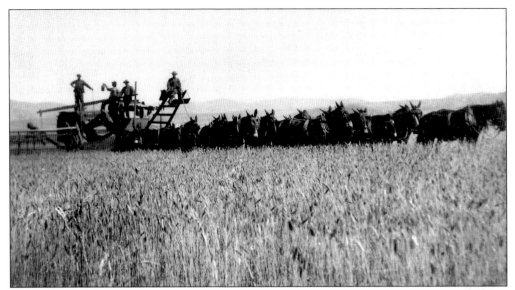

Horse power still prevailed for many, even as the era of increased production and high prices reached its apex in the late 1890s. A bushel of wheat sold for $1.25, and barley was $1.10 and upward, with yields rising from 10 to 40 sacks per acre. Although optimism was high, by 1900 this was changing, as was the weather. An editorial in the *Tehachapi Times* put the problem in context—"What we want here is rain." (Courtesy Tehachapi Heritage League.)

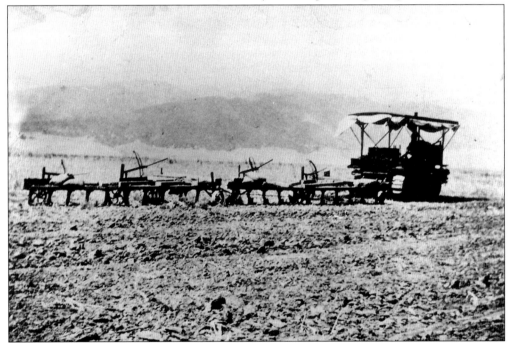

Mechanization allowed increased cultivation and hopes of increased production. Unfortunately this coincided with a drop in prices. Wheat, which sold at $1.92 a bushel, dropped to $1.01. Railroad freight charges increased and rainfall, needed for a bountiful crop, fell well below normal. In a December 1899 issue, the *Tehachapi Times* reported, "The promise of a good season next year does not help the people this one." (Courtesy Tehachapi Heritage League.)

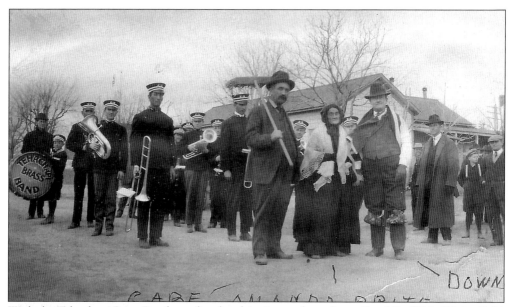

With the Tehachapi Brass Band standing by, this picture shows Lucas Franklin "Gabe" Brite (left) and his mother, Amanda Brite. Gabe had followed in the footsteps of his father, John, and was now in his third term as supervisor for the second district. Henry Downs (right) is preparing to fulfill his 1916 campaign promise to "push a peanut down Tehachapi's main street." (Courtesy Tehachapi Heritage League.)

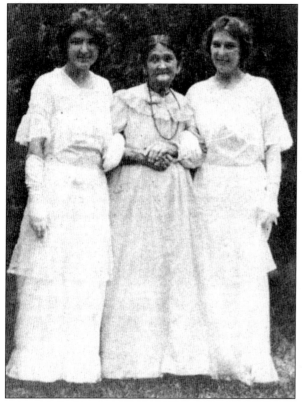

Pictured in 1910 are Gabe's daughters Ruby (left) and Bonnie (right) with their grandmother, Amanda, following the girl's graduation from high school in Bakersfield. The family stayed in town so the children could complete their education, and then returned to the ranch during the summer. Sons John Perry and Lucas Vance were ranchers although John, like his father and grandfather, was elected to the board of supervisors. (Courtesy Tehachapi Heritage League.)

Charles Henry Brite, pictured c. 1915, was the son of Joseph Henry and Lydia McKaige Brite. Little is known of Charles except that he appeared to be like his father, Joseph, who much preferred the rural life to politics. Joseph was the second son born to John and Amanda, and the first white child to be raised in the Three Valleys. Joseph and Lydia had four children, two of whom died as infants. (Courtesy Tehachapi Heritage League.)

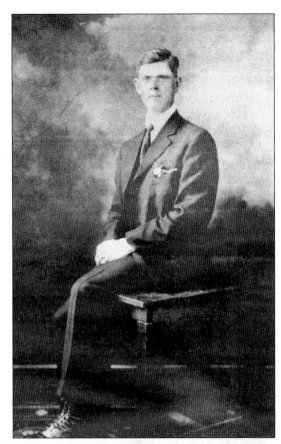

John Bright built this two-story frame house in 1880 to accommodate his and Amanda's growing family. Ten years later he divided the ranch among his sons and built another two-story Victorian house on the corner of D and Green Streets in Tehachapi. He died in 1893, and Amanda resided there until her death in 1917. The town was destroyed in the 1952 earthquake. (Courtesy Nick Smirnoff.)

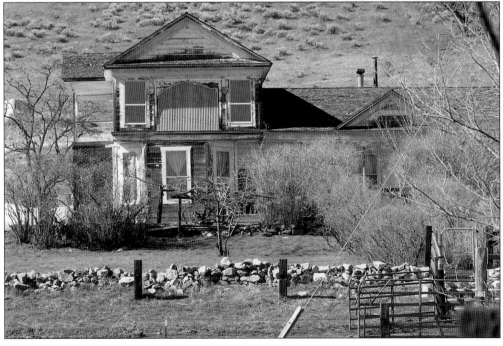

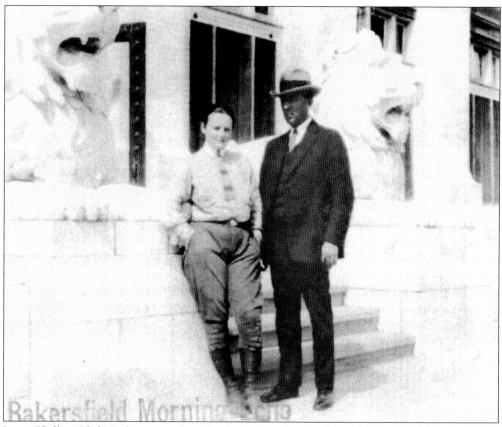

Louis Phillip "Phil" Fickert served as chief of police for the City of Bakersfield between 1926 and 1928. He was the son of John Louis Fickert (cousin to Fred Fickert), who had moved to Bear Valley in 1870 and, by 1891, had acquired considerable livestock, 3,000 acres, and a lasting dispute with his cousin. When Phil inherited the ranch, he sold it to the Tehachapi Cattle Company and moved to Bakersfield. (Courtesy Tehachapi Heritage League.)

Charles Marion Fickert is pictured here in 1909, when he was district attorney for San Francisco. Born to Fred and Mary Fickert, he was admitted to Stanford University in 1875. Following his graduation in 1898, he was admitted to the state bar. Following an unsuccessful bid for governor and a divorce from his wife, he returned to the family ranch in Bear Valley. In 1937, he died of pneumonia. (Courtesy Tehachapi Heritage League.)

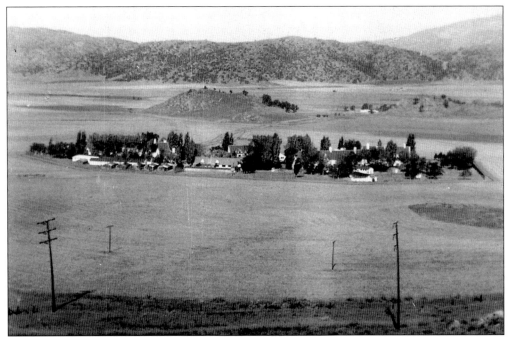

In 1930, the State of California purchased the Lucas Brite Ranch in Cummings Valley as a site for a women's prison. Three years later, the first contingent of inmates arrived to this unique 1,700-acre, pastoral setting. The Norman-style buildings were nestled amongst trees. Sheep and cows grazed nearby. (Courtesy H. Force collection, Tehachapi Heritage League.)

The Women's Department of San Quentin at Tehachapi underwent a name change in 1936, when the state created the first California Institute for Women. During the 1952 earthquake, the buildings were seriously damaged and the inmates transferred to another new facility at Corona, California. The prison then underwent a total reconstruction and, in 1964, became the California Correctional Institute at Tehachapi, a men-only facility. (Courtesy H. Force collection, Tehachapi Heritage League.)

Problems caused by the Great Depression, irrational weather, rising taxes, and expenses caused many farmers to seek someone to buy, trade, or lease their property. "We would make mighty interesting terms. We are sick of the worry." But there were no prospects. Many farms became a graveyard of plows, pipes, and windmills. (Courtesy author.)

The Williamsburg School, once called "the only decent structure in the town," became neglected and left to rot away. In 1944, shortly after this picture was taken, it was demolished. Ironically the lumber was set next to Tehachapi Creek, which flooded the following year and washed away the last remaining tangible vestige of Williamsburg. (Courtesy Tehachapi Heritage League.)

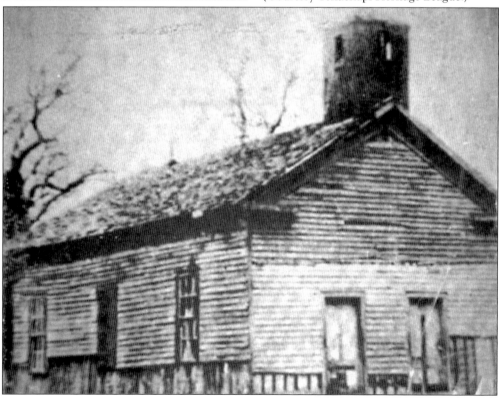

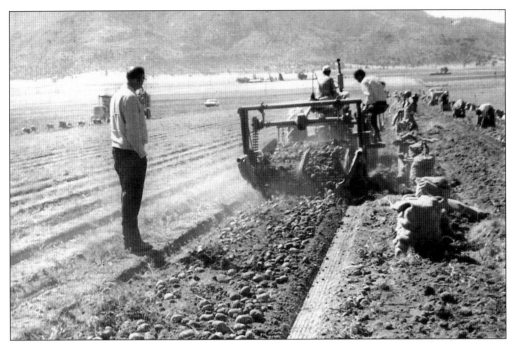

In the late 1930s, farmers switched to raising seed potatoes. After the start of World War II, there was a huge demand for table potatoes. Some 5,000 acres (most in Cummings Valley) were planted to Winter Russets. Machines brought the potatoes to the surface while 300 to 500 workers picked and sacked them by hand. Trucks followed the workers and transported the crop to market. (Courtesy Tehachapi Soil Conservation District.)

In 1946, farmers switched to raising sugar beets for seeds. Ben Sasia's Cummings Valley ranch yielded 6,700 pounds per acre. Don Carroll and J. B. Jacobsen started raising alfalfa for seed and for five years Cummings Valley was the center of the Certified Alfalfa Seed Industry in California. Barns held the bagged seed until it was shipped to buyers throughout the United States, to Canada, and to foreign countries. (Courtesy Tehachapi Heritage League.)

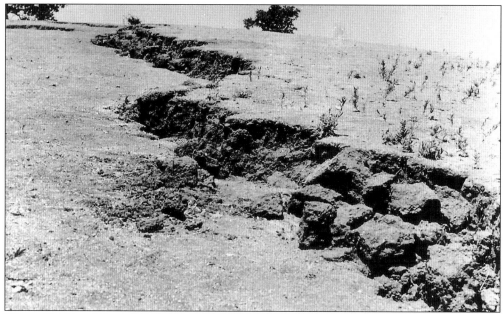

White Wolf Road (Bear Mountain Road) is shown after the July 21, 1952, earthquake. Measured at 7.7, it was said to have been the strongest shock in California since the 1857 quake at Fort Tejon and the 1906 San Francisco earthquake. The 6,900 foot Bear Mountain shifted three feet and displaced earth up to 10 feet. Some railroad tracks were twisted into an S-shape. (Courtesy Tehachapi Heritage League.)

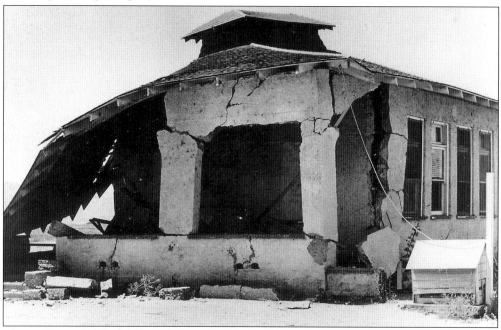

The quake caused the collapse of this Cummings Valley school, which was not in session at the time. Ten people were killed in Tehachapi, but only one death occurred in Brite Valley. A young woman was trapped beneath a rock wall that had fallen on her as she slept. (Courtesy Tehachapi Heritage League.)

There was no road into Bear Valley until the late 1880s, when the board of supervisors advertised for bids to construct a road "nine feet wide." By the time it was built, Fred Fickert had bought out most of his neighbors and had almost exclusive use of the road, which had changed little in this 1950s photograph. (Courtesy Dart collection, BVSA.)

Marshall Fickert, a third-generation Fickert, took over management of the ranch following the death of the sisters Louise and Nellie. The son of Charles and Ethel Fickert, he had spent the majority of his life in San Francisco as had his wife. As conservator and acting manager until the ranch was sold, he and his wife relied upon the good advice of his aunts' former friends and loyal employees. (Courtesy Dart collection, BVSA.)

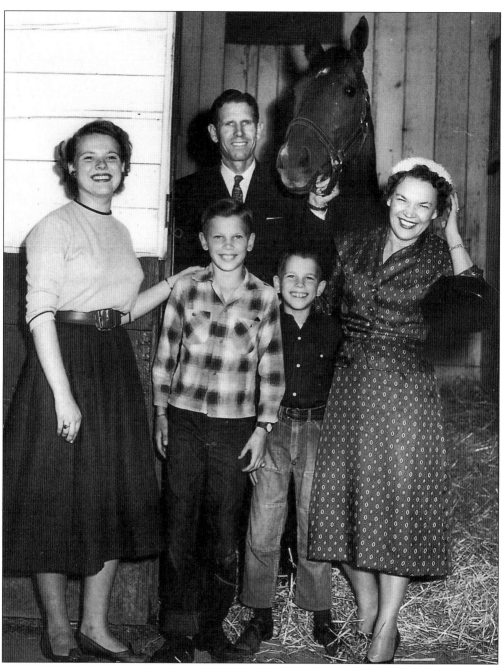

On March 1, 1952, a chestnut colt named Swaps was born on the former Hill Ranch now owned by Rex Ellsworth. In 1955, Swaps became the winner of the prestigious Kentucky Derby by one-and-a-half lengths. This photograph shows Rex Ellsworth and Swaps. In the front row, from left to right, are daughter Karmen, sons Kim and Kerry, and wife and mother, Nola. (Courtesy California Thoroughbred Breeder's Association.)

Swaps was named 1956 Horse of the Year. Out of 25 starts, he had 19 wins, 2 second places, and 2 third places. His wins were impressive ranging from 1.5 lengths to an 8.5 length (the Jefferson Purse at Churchill Downs). Swaps's trainer was Mesh Tenney, a boyhood friend of Rex Ellsworth. (Courtesy California Thoroughbred Breeder's Association.)

In the early 1960s, Ellsworth acquired a game breeder's permit and imported 500 North American elk to his Cummings Valley ranch. The animals soon scattered into the surrounding mountains as protected wards of the California Department of Fish and Game. Much to the delight of Bear Valley residents, this band of elk enjoys their protected environment. (Courtesy John Carnakis.)

Even before the turn of the century, some farmers were venturing into new fields. J. B. Phillips had earlier planted 600 cherry trees on his property near Old Town. His Black Tartarians (described as "simply perfect"), brought the unprecedented price of 10¢ a pound. He then added other varieties of fruit. Other farmers followed suit and by 1922, 5,000 acres were in orchards. (Courtesy author.)

Today eight small orchards in the vicinity of Brite Valley and Old Town are among the 20 active members of the Tehachapi Grower's Association. An annual brochure provides a map to members' orchards, with information on the 20 varieties of apples that are grown, and when they are open. The season runs from July through October. (Courtesy Tehachapi Grower's Association.)

Between 1961 and 1969, the ranches of Hill, Chanac, Cuddeback, Hicks, and Fickert were no more. In their place were planned communities with names such as Oak Knolls, Golden Hills, Stallion Springs, and Bear Valley Springs. The latter two promoted the area's resort-style living as an ideal place for a retirement or vacation home. (Courtesy Dart collection, BVSA.)

The gated communities of Stallion Springs and Bear Valley offered residents such amenities as tennis courts, swimming pools, equestrian centers, a fishing lake, golf courses, and restaurants. By 2005, the demographics had changed from retirement/vacation to permanent residency consisting of young families. Bear Valley remained the only gated community. (Courtesy Dart collection, BVSA.)

Prospective buyers at Bear Valley Springs were greeted with this scene at the gate. Sales associates went all out to provide guided tours, and chalet-style cabins were available to rent so one could enjoy the tranquil atmosphere for a few days before selecting a lot to buy. Stallion Springs provided an elegant lodge. (Courtesy Dart collection, BVSA.)

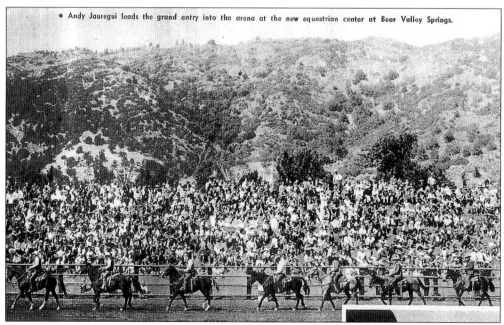

Casey Tibbs, six-time World Champion Saddle Bronc Rider, became consultant for the Bear Valley Springs' $200,000 equestrian center. His 1971 grand opening event was a reunion of current and past top rodeo contenders. Over 6,000 spectators watched the day long event. Chuck King, of *Western Horseman*, covered the event for a four page article in the magazine's December 1971 issue. (Courtesy Western Horseman.)

Dart Industries, Incorporated promoted Bear Valley Springs by hosting a number of special events featuring several sports and entertainment celebrities of the 1970s. Popular singer/actress Connie Hines (left) is shown here after winning a tennis tournament. (Courtesy Dart collection, BVSA.)

Lorne Greene (center) of the popular television series *Bonanza* is shown here with Monte Hall (right) of the game show *Let's Make a Deal*. On the left is Ed Weill, executive vice president for Dart Industries who arranged these celebrity tennis tournaments. (Courtesy Dart collection, BVSA.)

A Kid's Fishing Derby was among the promotions presented by Bear Valley Springs in 1973 and has since become an annual event. Cub Lake is kept stocked by the association and is a popular spot for anglers of all ages. (Courtesy Dart collection, BVSA.)

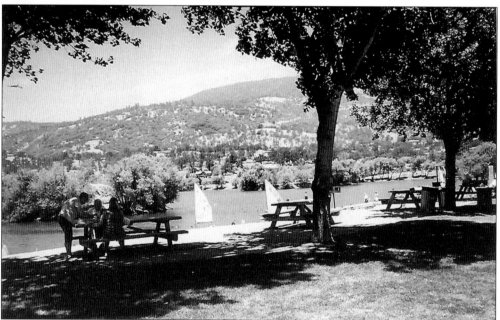

Picnicking and sail boating on Four-Island Lake in Bear Valley may also be enjoyed at the Brite Lake and Aquatic Recreational Area. This 90-acre lake in Brite Valley is open from April to October. It was created in 1973 to hold water imported from the Feather River as part of the action by the Tehachapi-Cummings County Water District to insure an adequate water supply and recharge of the Cummings Valley aquifer. (Courtesy author.)

This photograph shows erosion on Banducci Road during a flood that occurred in 1983. It wasn't until 1900 that procedures for tracking the weather became sophisticated enough to tally the following floods of record: 1913–1914, 1931–1932, 1938, 1945, 1955, 1958, and 1983. (Courtesy Tehachapi Heritage League.)

The same flood caused this section of Old Town Road to collapse. The establishment of watershed protection and flood prevention by the Tehachapi Soil Conservation District (formed in 1947) helped to lessen major flood damage. (Courtesy Tehachapi Heritage League.)

This picturesque bridge has become synonymous with Stallion Springs and was one of the first structures to be built by developer Benquet Corporation. The bridge and its rugged surroundings of oak trees, rocks, and water assume a different perspective according to the time of day or year. It's a favorite subject for artists and photographers. (Courtesy Nick Smirnoff.)

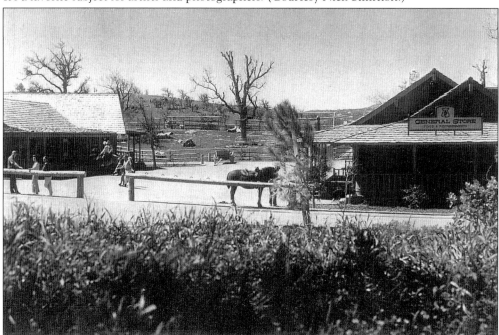

The western heritage of Bear Valley is emphasized with this rustic town center. It is the community's only commercial area and is limited to a general store and snack bar, realty office, and gas station. It is also the last resting place for the Bear Valley Schoolhouse (c. 1872–1900). The hitching rail shown in front has been replaced by a water-wise garden and moved behind the schoolhouse. (Courtesy Dart collection, BVSA.)

Seven

INTO THE 21ST CENTURY

The old settlers are gone. Only a few of the original homes remain. For some, their names are preserved in the valleys of Brite and Cummings. The vast ranches are no more. In their stead are developments such as Old Town Shopping Center, Golden Hills, Oak Knolls, Alpine Meadows, Stallion Springs, and Bear Valley Springs, where homesites range from city-sized lots, one-third of an acre, and up to 20 acres or more. Each has its own attractions to lure a new generation of families. Their respective Community Services Districts (CSD) oversee the infrastructure needs such as roads, water, sanitation, refuse disposal, etc. Residents of these developments remain politically active and elect their own to serve as directors on the CSD, the Property Owner's Associations, or as committee members to enforce the covenants and restrictions.

The green shoots of growing wheat and barley have been replaced by turf farms and golf courses. Horses are no longer the major means of transportation, but are now a recreational animal. Garden tractors, golf carts, and SUV's are the vehicles of choice.

The Three Valleys have entered the 21st century!

Black bears, such as this cub inspecting a resident's property, still live on Bear Mountain and make occasional forays into the domain of their new human neighbors. This no-hunting area provides protection to the bears, deer, coyotes, mountain lions, bobcats, raccoons, and foxes that have lived here for centuries. Among the many avian species represented are golden eagles and an occasional sighting of a California condor. (Courtesy Barbara Whelan.)

Golfers enjoy almost year-round privileges at both Bear Valley and Stallion Springs. The latter is the home of the Horse Thief Country Club, an 18-hole course open to members and non-members alike. Bear Valley's Oak Tree Golf Course has nine holes for residents only, and their guests. Lack of water, among other problems, caused the demise of the Golden Hills Country Club golf course in the 1980s. (Courtesy Nick Smirnoff.)

No fireworks is the rule for the Three Valleys, but that does not prevent residents from celebrating the Fourth of July. An annual occurrence on the holiday are hot air balloon rides in Bear Valley Springs. Going up, up, and away, balloon riders receive a real birds-eye view of the valleys. (Courtesy author.)

There are some 12 special districts in the Tehachapi area and of these, the Stallion Springs Community Services District (created in 1970), is one of the area's only two CSDs to maintain their own police department. The 2005 board of directors shown here, from left to right, includes David Aranda, CSD manager; and directors Irene Gunshinan, Paul Mueller, Tom Craft (president), Jim Keller, and Ralph Patrick. (Courtesy Nick Smirnoff.)

The Bear Valley CSD, created in 1970, provides its 8,000 residents and 110 miles of roads with a 24/7 police department, which includes its own dispatchers to handle 911 emergency calls. The 2005 board of directors, from left to right, are (first row) Phil Darling, Bob Sheppard (president), Ron Samuels (vice-president), and Al Romano; (second row) John Yeakley (general manager) and John Martin (assistant manager). Not shown is director Don Kordes. (Courtesy Nick Smirnoff.)

The Cummings Valley Protective Association (CVPA) has become the guardian of the agricultural and historical heritage of the Three Valleys. Through their volunteer efforts, agriculture remains

the dominant factor in Cummings Valley with emphasis on alfalfa hay, organic carrots, and turf farms. (Courtesy Nick Smirnoff.)

Every two years the CVPA provides a historical bus tour with local historians describing the old ranches in Brite and Cummings Valley. By special arrangements, visitors may visit one or two historic ranches. This tour member is seen admiring a metal sculpture of Pegasus on the ranch of actor Jack Palance and his wife, Elaine. (Courtesy author.)

The Mourning Cloak Ranch and Botanical Gardens includes some 2,700 plants, 80 of which are native to the area. Twice a year, owner Ed Sampson holds a plant sale at the ranch nursery. Garden tours, including his antique carriage collection, are available throughout the year. Mourning Cloak (named after the butterfly) is located on the former site of Williamsburg and has been featured on several television shows and garden magazines including *Sunset*. (Courtesy Matthew Chew.)

Ostriches have become one of the new industries to take hold in the Three Valleys. One of the ranches providing guided tours is Indian Point Ranch in Cummings Valley. Here visitors may learn the entire process of raising ostriches from egg incubation to fully grown adults. There is also a gift shop located on the ranch. (Courtesy Matthew Chew.)

Another new livestock industry has become part of the Three Valleys—raising Alpacas. These natives of Peru have adapted well to the climate and are raised either for pets or for their wool, which is of an extremely fine grade. These alpacas are on the Fire Horse Ranch, located in the vicinity of the Leiva homestead in Brite Valley. (Courtesy Matthew Chew.)

In 2003, the Bear Valley Springs Cultural Arts Association voted to initiate the renovation and preservation of the old Bear Valley Schoolhouse. All proceeds from the sale of this book will go towards this project. Board members who assumed this task, from left to right, include Gloria Gossard, Linda Haviland, Mardy Yurk, Bob Reynolds, Judy Reynolds, Lea Prentice (president), Rosemarie Schermer, Barbara Whelan, Nikki Keene, and Ginny Clark. (Courtesy Jim Yurk.)

Students of Monroe High School's video production class filmed a 20-minute presentation on the history of the Bear Valley Schoolhouse. Shown with their instructor, Deborah Scott (in the middle), are participants Gina Casey, Jeff Burge (camera man), and Jordan Marcioni. (Courtesy Bill Donica.)

Pictured here, from left to right, are Joe Fontaine (grandson of Joseph "Sam" Fontaine), Clarence Andersen, Bill Killmer, and Ralph Cazare. In 1950, they discovered this old cabin while exploring the timbered slopes of Bear Mountain. An old cabin, a rusted pump, or a broken wagon wheel all lend credence to the statement "history prompts many questions, but leaves few answers." (Courtesy Fontaine family.)

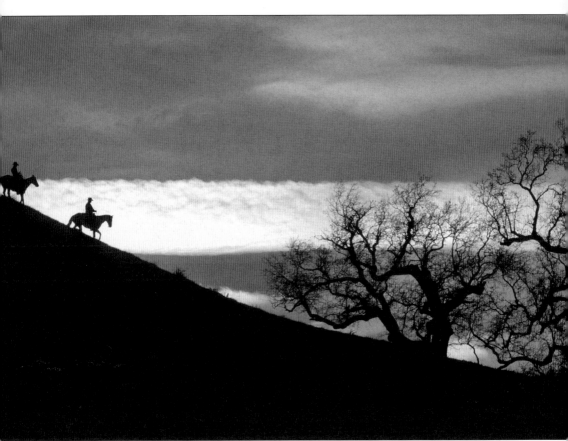

The journey through Three Valleys has come to an end. It's time to say goodbye. Two centuries of life experiences have been capsuled within these pages plus a glimpse into the future. The transition from Three Valleys into separate communities was created by the influx of strong, young families. And so it is today. Now it is time to ride off into the sunset. We've enjoyed being your guide and trust the feeling is mutual. Adios, compadres. Goodbye friends. (Courtesy Tejon Ranch Company.)